Carst
Hölle
Test
Site

Carsten Höller Test Site

The Unilever Series
An annual art commission
sponsored by Unilever

Published by order of the Tate Trustees
on the occasion of the exhibition at
Tate Modern, London
10 October 2006 – 9 April 2007

This exhibition is the seventh
commission in The Unilever Series

Published in 2006 by Tate Publishing,
a division of Tate Enterprises Ltd,
Millbank, London SW1P 4RG
www.tate.org.uk/publishing

British Library Cataloguing in
Publication Data
A catalogue record for this publication
is available from the British Library

ISBN-13: 978-185437-712-8
ISBN-10: 1-85437-712-4

Distributed in the United States and
Canada by Harry N. Abrams, Inc.,
New York

Library of Congress Cataloging in
Publication Data
Library of Congress Control Number
2006931286

Designed by Cartlidge Levene
Printed and bound in Great Britain by
Balding + Mansell, Norwich

Contents

It is an enormous source of pride to all of us at Unilever that for the last seven years we have been able to play a part in bringing some of the world's greatest artists to the truly unrivalled setting of Tate Modern's Turbine Hall. Millions of people from the UK and beyond have been able to see, hear, touch and enjoy great installations.

This year we are delighted to welcome Carsten Höller, whose installation Test Site has brought a playful and provocative perspective to the Turbine Hall. Test Site continues the tradition of innovation and experimentation established by previous artists in The Unilever Series.

This is an exploration that resonates within Unilever. An understanding of human nature is vital to a business that aspires to meet the everyday needs of consumers with products that make people feel good, look good and get more out of life.

As a Founder Sponsor of Tate Modern, Unilever is proud to have helped make inspirational contemporary art accessible to so many people through The Unilever Series.

We hope you will be enriched by Carsten Höller's work.

Patrick Cescau
Group Chief Executive, Unilever plc

Unilever

Tate Modern's Turbine Hall has become one of the most challenging and stimulating annual art commissions in the world, offering a succession of outstanding and memorable projects by leading international artists. Launched in 2000 with Louise Bourgeois's ambitious installation I Do, I Undo, I Redo, this unique space has hosted six diverse projects. We were delighted to invite Carsten Höller to create Test Site, an ambitious new work for the seventh commission in The Unilever Series.

Höller's work ranges from purely conceptual projects to elaborately architectural installations, almost always requiring the audience's participation to activate the works and give them their final form. Well used to working on a large scale, he demonstrates his central concerns relating to human behaviour, the playful questioning of logic and altered states of mind and perception.

Test Site is a new and significant development in an ongoing series of slides started by Höller in 1998. Tate's installation is the most ambitious in the series, infiltrating all of the museum's levels from the fifth floor to the Turbine Hall's bridge. It offers both an extraordinary visual event as well as performing a useful task in the building's system of circulation. Höller's interest in slides ranges from: their use as a practical and alternative means of transportation, in addition to the escalators and lifts in the institution;

and the effect of sliding itself, which involves a loss of control, vertigo and an emotional response from the sliders. The slides themselves, made from steel Makrolon constitute a striking sculptural work, filling the vast empty space at Tate Modern, and are to be explored as much from the ground level as from the different heights of the building's concourses. It is a highly formal composition of spirals complicated by the effect of a dramatic system of lighting. Test Site is an installation of complex resonances that needs to be experienced to be fully understood. Our sincere thanks go to the artist for realising this extraordinary project. His enthusiasm, intelligence and dedication have made this collaboration a real pleasure.

In creating Test Site, Höller has worked closely with Jessica Morgan, Curator, Contemporary Art at Tate Modern, who developed this project with dedication and professionalism. Jessica has worked closely with Carsten on all aspects of the work, from its inception to completion. Vincent Honoré contributed to the project as Assistant Curator. The various tests and the final installation were managed by Stephen Mellor and Phil Monk whose work with Wolfgang Hinze and Clive Newman of Josef Wiegand GmbH & Co. and Production Designer James O'Connell of EVENT was crucial in realising the project. A work of this complexity

necessitates dedicated input across Tate, particularly Ruth Findlay from Press and Marketing; Nicky White from Development; Emily Paget from Events; and at Tate Modern Dennis Ahern and Adrian Hardwicke.

Our efforts have been augmented by the unstinting help of Höller's galleries, in particular Esther Schipper in Berlin, and Gagosian in London, as well as Air de Paris in Paris, Casey Kaplan in New York, Shugoarts in Tokyo, Massimo de Carlo in Milan and Micheline Szwajcer in Antwerp.

This publication was edited by Carsten Höller and Jessica Morgan to realise a book closely related to Tate's installation. We are extremely grateful to Dorothea von Hantelmann whose essay offers important insights into the artist's work, Roy Kozlovsky who contributed an astonishing history of the slide, Clare Cumberlidge and David Knight from General Public Agency who have produced a remarkable feasibility study of the slide's potential use in London, and Farshid Moussavi from Foreign Office Architects whose project was to design a building whose structure and form was determined by the slide. This book is accompanied by a second publication, conceived by Carsten Höller as an artist's source book, a record of his rich textual references and works related to the several meanings and possible associations of the slide: from poetry to sociology, and from the state of altered consciousness to geometry. We would like to thank everybody who contributed to these books, in particular Ian Cartlidge and Ben Tibbs from Cartlidge Levene for their sensitivity to the project in designing the two books so elegantly, Alessandra Serri for sourcing the images, Sarah Brown for her efficiency in monitoring the production process and Judith Severne for managing the overall arrangement and completion of the publications.

Finally, we are enormously grateful to Unilever who are in their seventh year of sponsoring The Unilever Series of commissions for the Turbine Hall. They have offered us longstanding and unstinting support; we offer them, their CEO Patrick Cescau and UK Chairman Gavin Neath our most sincere thanks. Without this level of support, projects of this ambition and scale would simply not be possible.

Vincente Todolí
Director, Tate Modern

The invitation to produce a work for The Unilever Series of Turbine Hall commissions is no longer, if indeed it ever was, a straightforward proposition. Year by year, both the space at Tate Modern and the works that have been made for it have come to occupy a prominent and highly contested ground in art-critical debates. It has taken just six years and as many commissions to establish this project as a landmark in artistic events, but its nature has become increasingly complex.

The first commission in 2000 of Louise Bourgeois's three steel towers I Do, I Undo and I Redo, was somewhat overshadowed by the event of the opening of Tate Modern itself and the revelation of the vast Turbine Hall. In retrospect, the second commission, Juan Muñoz's architectural transformation Double Bind, perhaps came too early for an audience that had not yet become fully familiar with the space in its 'normal' state. Muñoz's extension of the bridge and mysteriously rising and falling elevators mirrored the industrial surrounding so effectively that the alteration of the volume and spatial experience of the hall might not have been fully appreciated. Both commissions, however, received unprecedented press coverage and by the third, Anish Kapoor's Marsyas, which made the significant leap over the bridge into the west and east ends of the Turbine Hall, The Unilever Series had established itself as a new type of platform for art.

It was without doubt, however, the fourth commission, Olafur Eliasson's The Weather Project – the most daring in regard to the relative youth of the artist – that propelled this commission out of the realm of the art world and into the domain of the public event. There can be few people in London with even a small interest in contemporary art, who are unfamiliar with the giant sun that set day after day at the east end of the Turbine Hall. Not entirely in accordance with the artist's intentions, the work became not only a meeting place, but a location for events and protests, picnics, yoga and photo opportunities, an excuse to gaze narcissistically at one's own reflection on the mirrored ceiling, and, above all, a reaffirmation of the ability of art to create an overwhelming sensation of spectacle and splendour.

It is the latter effect, in combination with the scale of the Turbine Hall, which each commission had so far responded to by competitively filling, or in the case of Eliasson enhancing, that has come to be the subject of critical assessment. This evaluation links the display in the Turbine Hall with the 'spectacularisation' and expansionism that has dominated every aspect of the art world over the last decade – from ambitious museum buildings and franchises to big-money art markets and fairs, and from global artistic production

to the blockbuster exhibitions, large-scale installations, events and celebrations that have come to be accepted as normal artistic production. Critics like James Meyer (writing in 2004), have seen the Turbine Hall commissions as both generating and affirming these conditions, rather than – as was the original intention of Eliasson's project – establishing the type of phenomenological awareness of scale and space that enables a questioning of the surrounding institutional environment and provoking critical thought.

It is not just the scale of the projects in the Turbine Hall that have contributed to their unique status, however, as was proven by the relatively immaterial sound project Raw Materials by Bruce Nauman in 2004. And although the openly accessible Turbine Hall is perhaps the main attraction, Tate Modern as a whole, which is free to the public, has drawn unparalleled numbers of viewers. The massive crowds that have flooded through Tate's doors (now reaching an average four million a year) have become another cause for critical concern: they have necessitated the type of crowd-control previously associated only with stadium concerts and airports, art is consumed, or simply passed by, and a different relationship to the artwork and the gallery has been established by this relentless throng of people. The somatic

scale cherished by Meyer and other critics of Tate Modern, as opposed to what they perceive as the diminishing returns of the ever-larger work of artists such as Richard Serra, or Eliasson's The Weather Project, is in danger of being lost in the crowds that dwarf every artwork placed in the context of Tate Modern.

But must this be something to be only reviled? Are these record numbers of viewers not demonstrating an interest that, though inapplicable to a contemplative and contiguous relationship to an artwork, is still something to be explored and maybe even challenged? Though some might argue that the problem lies in creating the Turbine Hall and in particular designating it as an art space, it seems oddly perverse to insist on an experience of art as limited to a certain scale or to a particular type of appreciation. The 'publicness' of the museum, has after all, historically been at the heart of its mission, and though we may occasionally lose one form of artistic experience, surely there is the potential for others.

The phenomenological experience of scale is indeed just one lineage in the history of postwar art. One could track another, not entirely unrelated, path that extends from Allan Kaprow and Dieter Roth to Paul McCarthy and Thomas Hirschhorn, which gladly embraces a 'more is more'

aesthetic in work that is constructed not from a single monolithic form but through the accumulation of props, commodities and trash. Here, materiality and its vast scope for chronology – from the daily process of decay, to the history of civilisation, and the geological time of place – points to a view of existence as an endless struggle to order the ephemeral debris of the world, an attempt to overcome an inevitable slide towards ruin. Rachel Whiteread's Turbine Hall commission EMBANKMENT could be said to have gestured, albeit monochromatically, in this direction and the theatrical or staged aspect of these works provides a different perspective from which to understand this notion of scale without relinquishing a critical standpoint. Similarly, a recent history of art concerned with staging the everyday embraces scale by slyly incorporating willing participants into the arena of the work, and by extension, framing the surrounding space – be it gallery, urban street or landscape. Here, the physical object of art has on occasion been completely eliminated, and the institutional or public space turned into a changeable and constantly performed or staged field in which the audience is central as player or performer. It is within this lineage that the work of the latest artist commissioned for The Unilever Series, Carsten Höller, emerges.

At first glance, Höller's project for the Turbine Hall appears to be a blatant confirmation of the dominance of spectacle-as-art. A series of five slides departing from the fifth, fourth, third and second floors, all arriving under the bridge of the Turbine Hall, suggests the ultimate realisation of the twenty-first-century art museum as entertainment zone. But these slides are conceived not only as a pleasure-inducing ride, though this in itself – as is eloquently explored in Dorothea von Hantelmann's essay in this book – is far from a simplistic concept in Höller's work. They are also designed as a practical means of transportation that has the additional benefit of inducing a physical experience quite unlike those encountered in everyday life. These slides are temporary, but Höller's ambitions for them are far from fleeting. His proposal is that the slides, as well as the ideas, plans and discussions contained in this volume, are a grand advertisement, propaganda even, for the use of slides in our everyday landscape and architecture. The slides at Tate are just a step further towards their inclusion in future architectural projects.

Tate Modern, with its problematic circulation – who visiting the museum has not waited for the lifts or frustratingly been swept past the second level by the escalator that mysteriously refuses to stop there – is the perfect environment in which to demonstrate the practicality of slides. Placed conveniently on each gallery level, a fast journey is guaranteed and with no unwelcome

stops at another visitor's behest. Aside from the decidedly uni-directional nature of the slide, it is in all other aspects highly practical: safe (arguably more so than escalators, lifts and stairs), fast, compact, accessible and even environmentally friendly. As can be seen in the proposal in the following pages by the architectural practice Foreign Office Architects, the slide can even be used as a structural element of a building, and though Tate's slides are all destined for one endpoint, there is no reason why slides cannot connect different floors or even buildings – as demonstrated in the other enlightening study here, by General Public Agency.

But efficiency is not generally a concern that we would associate with the work of Höller, an artist known for his interest in doubt, rather than certainty, and experimentation over conclusion. Of course, there is more to his espousal of the slide than simply an interest in improving our means of egress. The unique quality of the spiral slide, unlike any other form of commonly used pedestrian circulation, is the physical experience of abandonment and vertigo induced by the circular movement of descending. Höller's main thesis is that the daily effect of sliding, and with it the introduction of a regular dose of exhilaration, joy and lack of control, will have a transformative effect on our behaviour. To slide on the way to or from work, as an interruption to the drudgery of commuter travel, could, once undertaken as a routine activity, subtly alter our outlook. The thrill and vertigo currently circumscribed to the playground or fair would provide an altered perspective, the results of which are being tested at Tate Modern for the first time.

Höller's speculation on what this effect might be is hinted at in the material that he has gathered together for the second of the two volumes accompanying his project at Tate, Test Site: Source Book. This second volume brings together materials that impressionistically demonstrate the extensive and potentially profound reach of the network of ideas and resonances that are connected to both the slide and sliding. Amongst the selection of architectural and natural forms, mathematical tracts, philosophical extracts, images, stories and scientific studies, we find, for example, an extraordinary account by the early twentieth-century, Paris-based writer and scholar René Daumal on his youthful experimentations with experiencing the onset of death, induced intentionally by the inhalation of carbon tetrachloride. Speaking of a 'curved' sense of duration, vertigo and repetition as the dominant structures in his memory of this experience, his description is uncannily close to that of the effect of sliding. Also included in Höller's selection is a chapter from Stephen Jay Gould's The

Panda's Thumb on the evolutionary debate between Lamarckism (the inheritance of acquired characteristics) and Darwinism (natural selection). It is unlikely that Höller is actually supporting a Lamarckian viewpoint and proposing that, after centuries of sliding, humans might, for example, develop a padded back for more efficient decent. Gould's conclusion, however, that Lamarckism, though hard to defend in biological terms, seems to characterise cultural evolution, whose impact is felt far more rapidly than any biological change, is perhaps key to Höller's selection. Why stop at escalators, lifts and stairs, he seems to ask, when we could advance to the state of sliding? Indeed, Roy Kozlovsky's meticulous account of the history of the slide that was undertaken for this book confirms that it was only relatively recently that the slide was incorporated into the realm of playground and entertainment activities and thus its own technological evolution is relatively young. Through the images in Test Site: Source Book of naturally forming spirals (shells and hair), as well as the presence of the coil in architectural and graphic design, Höller suggests that the form and physical experience of the slide is manifest in all aspects of our biological and cultural world and that we have yet to fully appreciate its potential and significance.

　　To return to the question of scale and spectacle, taking into account Höller's grand ambitions for the slide – which amount to nothing short of a re-evaluation of the accepted forms of descent in architecture – his project is undoubtedly the largest in scope that the Turbine Hall has witnessed. And where better to present an argument such as this than on a stage as prominent and public as Tate Modern? Where else could one be given the opportunity to introduce the slide into the workings of a public building with a guaranteed participative audience of millions? A conversion in architecture and experience such as this could never be achieved by the quiet incursion of the small-scale project. But, viewed from this perspective, the Turbine Hall can be seen as a relatively minor platform, a modest beginning for the wide-scale transformation of behaviour, and most of all, experience, proposed by this project. In our critique of the spectacularisation of culture, therefore, it is important not to dismiss en masse all works that aim to operate on such a public level and in a manner other than the mode of phenomenologically oriented critique. As Höller's Test Site will prove, there is a transformative effect in the exhilarating, joyful, disorienting, vertiginous experience of sliding. After 10 October 2006, 'to holler' may come to have quite a different meaning.

Jessica Morgan
Curator, Test Site

Dorothea von Hantelmann Essay

|

Dorothea von Hantelmann

Much has been made of doubt in reference to the works of Carsten Höller. Since the artist launched his <u>Laboratory of Doubt</u> in 1999, notions of doubt and uncertainty have become key concepts in almost every discussion of his practice. The works are seen as metaphors for a doubtful state of mind or as sculptural devices that produce doubts about how we perceive, understand and relate to the world. Doubt, as a weak, unstable and unproductive condition, is thereby promoted as a driving force against the modern subject, which is ideally confident, self-transparent and self-assured.

And yet, although I have been following Höller's work for quite some years, this interpretation has never fully made sense to me. Apart from the fact that today, probably every successful artwork questions certain aspects of the world (while affirming others), I not only find it difficult to accept the subversive quality of doubt, but would also question the stress laid on the idea of doubt when it comes to the actual experience of Höller's art. My impression is that the accentuation of doubt can be misleading because it overshadows the different and at times even antithetical effects of Höller's works. The slides, for example, are neither about doubt nor distance. Quite to the contrary, they seize the visitor and involve him or her in an experience of the here and now that renders doubt or any critical distance to the world impossible. Sliding makes most people happy. It is, first and foremost, fun, a bodily and mental sensation that brings back a kind of childish joy that is the very opposite of the distance that doubt requires. So maybe doubt is simply the incorrect term. [1] We can speak of a physical and maybe even a mental destabilisation that takes place, but this is not doubt.

Höller has often mentioned his interest in non-utilitarian, seemingly useless, senseless and unproductive ways of thinking, feeling and being, such as devotion and exaggeration. These are conditions or states of mind that serve no specific purpose yet have a transformative impact on the way we are and the way in which we relate to ourselves. One could think of other mental activities that are equally senseless or useless, such as amazement. The state of amazement or astonishment might at first seem similar to doubt but in fact it is something very – even categorically – different. Doubting is practised by the rational and reflective mind. And – which brings us back to its supposedly subversive qualities – it is an activity that by no means undermines the subject's stability; rather, it constitutes an integral part of its very construction.

For René Descartes, philosophy begins with doubt, since it is only in

Fig.1
Light Wall 2000/2002

Fig.1
Light Wall 2000/2002

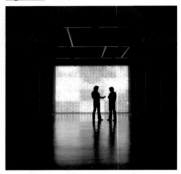

Fig.2
Mirror Carousel 2005

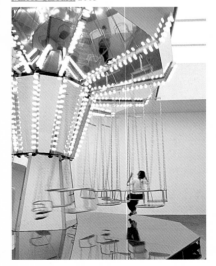

doubt that certainty can be reached. Doubt – the uncertainty as to whether a claim, perception or way of living is right or wrong – is the necessary condition and path by which to reach the conclusion of fixed and certain principles. Doubt requires the ability to reflect, to create a distance towards oneself and one's own beliefs or assumptions, the same distance that opens up a space for critique. Therefore doubt is as fundamental to a modern idea of the subject as is critique. Both are techniques employed to create distance, to discern and to judge. By contrast, astonishment implies the abolishment of distance. The state of amazement is a transitory moment, in which the clear distinction between subject and object, being and appearance, is suspended. It is a moment in which there is precisely no reflection and no judgement; it is simply being in and with a situation. To be amazed means to be captivated in a purposeless state of absorption that does not need to lead anywhere. From this perspective, we can understand doubt and amazement as being two opposite modes of questioning. The one is linked to the figure of the Enlightenment, to man's ability to reflect and to produce distance, the other stems from a position of affirmative identification.

If we situate Höller's works on a scale whose opposite ends are doubt and its overcoming, then the slides are about as far as one can go towards the

latter extreme. They are among the most vital and life-affirming artworks I know. Their purpose is to make people feel joy and happiness – which for an artwork is quite an ambition. Another reason why the slides could be seen as antithetical to doubt is that, apart from producing a state of mind that renders doubt impossible, they also rely on forces that are above doubt. Similar to Höller's Light Wall (fig.1), the slides reconnect the visitor to a physical self that is subjected to the effects of natural constants such as gravity that are beyond our control – and beyond our doubt. There is an interesting pairing of will and powerlessness at play when the visitor approaches this work. He or she actively decides to become passive, to be moved and manoeuvred by an object. Once you slide, there is only one way to go, and once you go, there is no way to stop. And because there is almost no possibility of controlling the process, you might as well give up control. You have to surrender to the experience of speed and gravity. This is the moment in which – ideally, and for some people literally – a physical and mental transition takes place: from a state of reflection, critical distance and, at times, also doubt, to an experience of ecstasy, of being out of oneself and in a state of life-affirming absent-mindedness, before one reaches the end of the ride and, still off-balance and a little dizzy, readjusts one's senses and sensibilities to the stable ground.

It is no coincidence that the slides, like many of Höller's works, are in fact vehicles (fig.2). They represent, and actually produce, a rite of passage, a mental and physical displacement, a transition in which we experience a different, non-utilitarian and therefore barely accessible side of ourselves. There is a Nietzschean dimension to this concept, in the sense that – unlike in the philosophical tradition of modern times – it does not address the self from its rational and reflective side, but from its absent-minded natural ground. Nietzsche was fascinated by any kind of delirium that brings the subject closer to his or her own dissolution. The slides evoke such a loss of stable ground in the phenomenon of vertigo, which – as a somatic effect – can at times even lead to illusionary perceptions. This is caused by the liquid in our organ of equilibrium, which, after an abruptly halted rotation around one's bodily axis, continues to move for a while. Because the perception of movement lasts longer than the actual activity of the body, we have the impression that it is now the surrounding world that moves. The somatic phenomenon of vertigo signals the failure of a coherent coordination of self and world perception. As an aesthetic and cultural concept, however, it comprises a narration that goes from the fragility of the self to the evanescence of the senses and a sense of dizzyness, to finally reach the joyful experience of

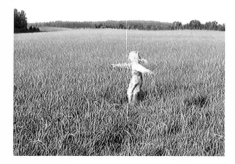

Fig.3
Video still from Jenny 1992

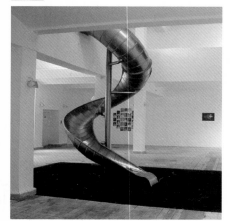

Fig.4
Valerio I 1998

vertigo, an attraction that confronts us with the limits of our sensual orientation (fig.3). As the various cultural devices that produce vertigo prove, this can be a moment full of relish. There is something anarchic about it that is directed against an only supposedly 'stable' normality. This is the kind of questioning that the slides engender. It is not doubt, led by a reflective critical mind, but an exploration of the world with the body and the senses, driven by a positive and absent mind.

Some of Höller's early slides (he has built six so far, of which two remain) have the title 'Valerio', such as Valerio I and Valerio II, produced for Kunst-Werke Berlin in 1998, and Valerio III, installed at Kiasma in Helsinki in 2000 (figs.4, 5, 6). The name refers to what the artist calls the 'Valerio phenomenon':

The Valerio phenomenon ... supposedly originated at a rock concert in Italy last summer. It's an interesting example of mass hysteria. A sound technician at a concert disappeared, and someone in the audience, pretending to know his name, shouted 'Valerio!' More and more people joined in. It was, apparently, infectious, and it spread from Brindisi to Rimini and other cities. There is something about the sound of this name that makes you want to shout it loud. You feel a little better after you've done it, just like after having traveled down a slide.[2]

The Valerio phenomenon and the experience of sliding, then, share a similar vital energy. Whereas the one is contagious and ultimately creates a community – however fleeting – joined together by a moment of constructed hysteria, the ecstasy experienced in the slides, which makes some people scream out of joy or fear or both, takes place in the body of the individual visitor. In both cases, however, there is a transformative power at play – a kind of Nietzschean force that strives towards altered states of feeling, being and existing. These altered states of mind, these different qualities and intensities, are neither deep (in terms of a more profound meaning), nor enduring. Yet they are powerful, for – even if it is just for a very brief moment – they have a transformative impact on the one who subjects himself to them. They stretch the boundaries of the body and of the I; in Höller's words, they 'extend the personality'.[3] The Valerio phenomenon cultivates this potential as a kind of everyday technique. The slides, however, introduce it into the museum. Being the place where our most differentiated ways of relating to objects and their symbolical meaning are displayed and cultivated, the slides bring in a moment that is all about one's relation to oneself. In Höller's works the object becomes a tool, a device to produce these moments. Sliding down Höller's structures, one does not communicate with the sensitivity or the specific subjectivity of the artist – as we might do when we contemplate other artworks such as e.g. a drawing – but with oneself. Or rather, one communicates with a different side of oneself. The fact that we do this is, of course, his idea. But in the experience of the work, we are confronted with ourselves, and especially with our physical selves, more than with the artist. The sculptural object, in other words, becomes a tool to explore and experiment with our selves. It not only serves the perception of one's self, but engenders a transformation of one's self. This operational dimension is crucial: the work seduces us to act upon ourselves.

Nietzsche's dictum, that the problem of science cannot be comprehended on its own grounds, and that he therefore wanted to see science under the optics of art and art under the optics of life, leads him at some point to think of culture as a bicameral system. Prefigured by (though not identical to) his early distinction between the Apollonian and the Dionysian, he comprehends art and science as two different and antagonistic forms of expressing life. Whereas art, for Nietzsche, operates with the creational, vital and transformative forces of life, science has a rather regulative function. 'In the one domain', Nietzsche writes in Menschliches, Allzumenschliches (Human, all too human), 'lies the source of strength, in the other the

Clockwise from below: <u>Valerio II</u> 1998; <u>Female Valerio</u> 1999; <u>Slide No.5</u> 1999/2000; two views of <u>Slide No.6</u> 2003

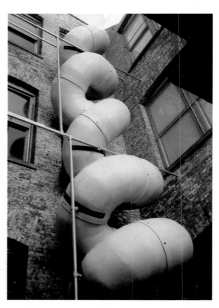

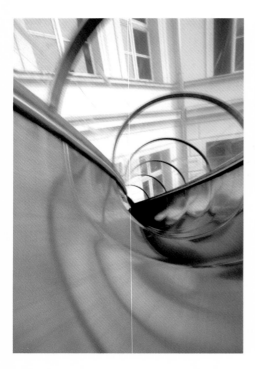

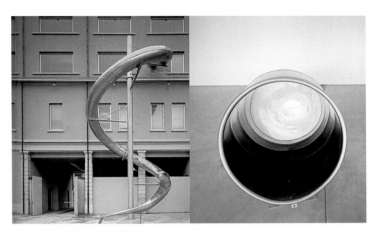

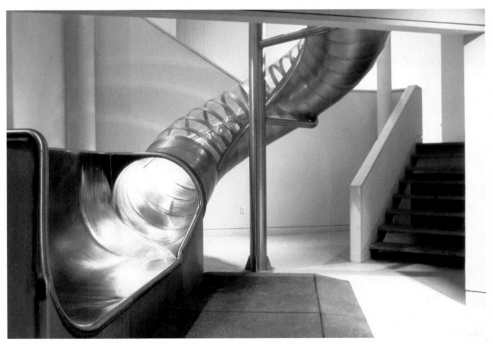

Fig.5
Valerio II 1998

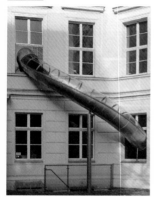

Fig.6
Valerio III 2000

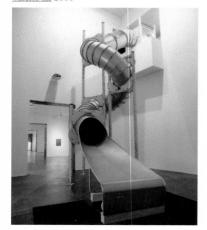

regulator. Illusions, biases, passions must give heat; with the help of scientific knowledge, the pernicious and dangerous consequences of overheating must be prevented.'[4] In this model, science is regarded as a balancing power that – in its methodological distance – regulates the vitalist and creational forces of life. Art and science both inform culture in different ways that Nietzsche describes in terms of tempers and temperatures. While art is, in his words, a 'heating' up, intensifying and enhancing situations, science is a 'cooling' down and functions as a mirror for a stock-taking of oneself. This perspective on the relationship between art and science could be illuminating in relation to Höller, who – for the right reasons – has always dismissed the concept of interdisciplinarity in his practice. Only if we think of art and science as two autonomous realms does it make sense to be interested in transgressing their borders towards the creation of an interdisciplinary field. With Nietzsche, we can comprehend art and science not as disciplines, but as different kinds of energies that inform aesthetics in antithetical ways. Both play a role for Höller, and their relationship creates a certain tension that underlies many of his works. Rather 'cool' in form, they seem to take up the 'hot' aspects of science, the joy in and enthusiasm for experiment and exploration.

When Nietzsche speaks of art's potential to create intensities and vital energies, for him these creations are extraordinary – but they need not be true. While the scientist deals with truth and its cognition, the artist, after Nietzsche, creates and transforms reality. This brings us back to the slides and to the phenomenon of vertigo, since vertigo is a borderline state that marks not only the transition from stable to unstable ground, but also from truth to lie. In German, the word *Schwindel* (swindle) refers to the somatic sensation of vertigo, but it also signifies a minor lie. The loss of orientation in space corresponds to a loss of orientation regarding what is right or wrong. In this sense, we could understand the slides as a transition not just to a different dimension of experience, but also from the paradigm of right and wrong to a realm of becoming and efficiency, of art's potential to create and transform reality.[4]

In 1996, Höller staged an exhibition titled Glück/Skop (Happiness) (fig. 7) that contained a series of objects and sculptures, instruments and proposals to engender happiness, or to examine the impossibility of engendering happiness. Nothing could be further away from an objective right or wrong than the notion of happiness. With this exhibition, Höller became most explicit with regard to the question of what improvement and well-being could mean today. And, one could add, to the question of how art can address this issue without touching on mystic truths. It might be illuminating to refer to Michel Foucault at this point, for whom the art of living was a subject that he reflected on, using Nietzsche as – in Foucault's words – a 'permanent tool'. For Nietzsche, the notion of the subject – quasi as an artificial bracket – describes a multiplicity of inner states of being that in reality elude from any unitary organisation. The consistent I remains a fiction that is merely suggested by grammar. In the actual experience there is no corresponding to the notion of an identical subject. If we follow Nietzsche, the human being is not unisonous, but has several voices, which gives him the chance, but also condemns him, to experiment with himself. As a 'dividual', he can and must relate to himself. Since 1966, Foucault had represented the project to revise the modernist ideology of the sovereign confident subject, and had spent decades working on the position of the subject in relation to power and knowledge. In the 1980s, he returned to the question of the subject from a different perspective. He was no longer primarily interested in a critique of the notion of the subject that descends from the Enlightenment, but rather in the techniques and practices through which the individual can and must create and recognise himself as a subject. Foucault, in other words, explores the 'culture of oneself' and the diverse technologies

Fig.7
<u>Glück</u> 1996

Fig.8
Pages from <u>Carsten Höller's Spiele Buch</u> 1998

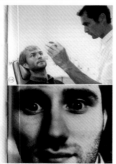

for taking care of oneself. As a context, we must understand that there are four major types of these 'technologies', each a matrix of practical reason: (1) technologies of production, which permit to produce, transform, or manipulate things; (2) technologies of sign systems, which organise the use signs, meanings, or symbols; (3) technologies of power, which determine the conduct of individuals and their interpersonal relations; (4) technologies of the self, which permit individuals to effect by their own means or with the help of others a certain number of operations on their own bodies, their conduct, their thoughts and their souls. Foucault's phrase 'technologies of the self' refers to the sum of these techniques that allow individuals to purposefully work on and transform themselves in order to attain certain states of happiness, purity, wisdom, perfection or immortality. What makes his approach interesting in relation to art is that it leads one's attention to the creative potential of the individual without going back to the modern notion of the subject that is usually attached to the concept of creativity. Rather, Foucault understands creativity from its technical side, as a capacity to acquire techniques and to use and apply them in specific ways. Creativity, in other words, is no longer the expression of the antecedent individual. It refers to the techniques that we use to construct ourselves as individuals.

The notion of art as a reflection on and proposal for techniques to act upon one's relation to oneself, to form and to transform oneself, is central in Höller's practice in general. Projects like his <u>Spiele Buch</u> (Book of Games, 1998; fig.8) focus on this idea, and it is also referred to in titles of such works as the <u>Expedition Equipment for the Exploration of the Self</u> 1995. The slides, however, stand out by effectively operating on the visitor in order to create this transformation. In the nineteenth century, artists such as Novalis, Gustave Flaubert or Stéphane Mallarmé related the joy of falling and the enthusiasm for the loss of consciousness to 'female' symptoms such as migraine, sickness and fainting. These examples represent an I that – similar to the combination of omnipotence and powerlessness that characterises the ride down the slides – puts itself in a self-produced state of excitement or irritation. The joy of the self-produced vertigo is the joy of creating a space in which the I faces a self-created Other. The subject constitutes itself in and through experiences that are always mediated by an exterior. It is through the other that the self comes back on itself to transform itself. In Höller's practice, the object is a tool to engender such a movement away from and back to oneself. Or, as the artist puts it: 'It is not you and the object: the object and you are you. It's all you. But I should say, it's all "yous".

Because there is no one ˏ at least two yous.'[6]

The idea of the artwork as a tool with which to transform one's inner person has a long history in visual art. In the context of contemporary art, however, Höller's slides, like <u>Light Wall</u> and <u>Flying Machine</u> 1996 (fig.9), could be seen as part of an artistic practice of experience creation. The notion of 'experience creation' signals a fundamental shift in the way in which the meaning of an artwork is understood: from a level of intention, expression or content to a dimension of effect and experience; from what an art work 'says' to what it 'does'. The German art historian Oskar Bätschmann has called the artist a 'creator of experiences' in relation to modern and contemporary art. His primary reference figure is Bruce Nauman, who, after having used his own body and subjectivity as a material for his art, between 1969 and 1974 produced a series of corridors that assault visitors with precisely constructed bodily and sensual experiences. They pass through freestanding walls, are mellowed by swathes of light, hear the recorded laughing, screaming or breathing of the artist and at times are requested to follow certain instructions. Best known are the corridors in which the visitor is confronted with his or her mediated image or, correspondingly, with the withdrawal of this image.

Clockwise from below: <u>Slide House</u>
<u>ect (Independent Monument Accra No.1/1)</u>
<u>/99</u>; <u>Slide House Project (Skyscraper Abidjan</u>
<u>No.1/2)</u> 1999; <u>Skyscraper Slide Connections</u> 1998;
<u>Slide House Project (Marcel's Favourite House Accra</u>
<u>No.1/1)</u> 1999; <u>Slide House Project (National Theatre</u>
<u>Accra No.1/1)</u> 1999; <u>Slide House Project (Space</u>
<u>House Accra No.1/1)</u> 1999

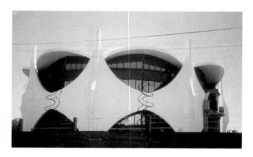

Fig.9
Flying Machine 1996

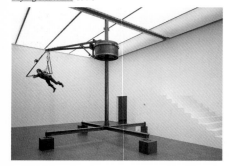

Fig.10
Upside-Down Mushroom Room 2000

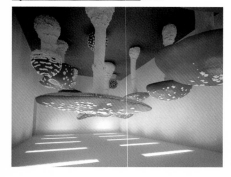

What all these pieces have in common is their operational character. They provoke and act upon very basic and existential forms of experiences, such as constraint, powerlessness or the deceit of narcissism. While Nauman's works strive to lay bare the human condition in all its limits and constraints, Höller is more interested in examining the self's potential or inability to free itself from these constraints. Nevertheless, there are striking parallels between the corridors and the slides. This is not just true of their focus on fundamental modes of being in and relating to the world (if we follow Nietzsche and think of vertigo as an indicator of the insecure and ambivalent constitution of the human being, the phenomenon of vertigo is also an experience of the human condition), but also of the way in which they relate an experience of the self to an experience of a specifically arranged spatial and mental environment.

Another artist, who – at his best – is a creator of experiences that strive to transform one's inner person, is Jeff Koons. And again we can find some aspects that are parallel to Höller's practice. Both artists are interested in a kind of subversion of values. When Koons claims that art should raise 'trust' – at the end of a century that had elevated the questioning of the notion of art to its primary principle – he seems to position himself as anachronistic to a hegemonic understanding of

contemporary art, just as Höller does with his affection for art that produces joy, happiness and absent-mindedness. In fact, Koons's giant Puppy outside the Guggenheim Bilbao and Höller's slides both turn the museum into a kind of playground: Koons by making it the backdrop for a monumental organic, vital and life-affirming flower-sculpture in the shape of a dog, and Höller by evoking an experience with his slides that has an equally 'childish' and optimistic quality. Both Koons and Höller shift the significance of art away from a level of content, narration and opinion towards its potential to create effects and experiences. They focus on the performative potential of an artwork, on its capacity to produce and transform reality (fig.10). And in striving towards an experience that is generous, celebratory and integrative, for both artists this focus on art's transformative potential is directed towards a transformation of values, or, as the French philosopher Jacques Rancière calls it, towards a 'reorganisation of the distribution of the sensible'.[7] The visitor's experience is thereby not just an important part of the artwork; it *is* the work and it is the *meaning* of the work. The object becomes a device to transform us, to make us feel and exist differently. This cannot be right or wrong; it can only succeed or fail.

Does this introduction of ecstasy and absent-mindedness into the museum mean to affirm this institution as a place for spectacle? Considering the fact that Tate Modern's Turbine Hall is certainly one of the most spectacular places that exists for the display of art today, this question is legitimate. Yet, not everything that is fun is necessarily a spectacle, at least not in the sense given to the term by Guy Debord, for whom the spectacle signals a specific state of alienated, reified and soulless experience. The spectacle is the substitution of human relations by images. The immediate experience gives way to mere representations. From this perspective, a work like Olafur Eliasson's The Weather Project, created in 2003 for the Turbine Hall, is much closer than Höller's slides to spectacle. While Eliasson cultivates the spectacle of contemplation in relation to a romantic idea of art and nature, Höller, in working with the pragmatic and operational character of an artwork, is as remote from the notion of contemplation as he is from any romantic perspective on art or nature. Both artists relate to the museum and to the forms of experience that the museum has developed. Yet they do this in almost antagonistic ways: Eliasson works from within and as part of a tradition that Höller quite radically undermines.

From its historical beginnings around 1800 onwards, the museum has developed as a place where representation meets specific forms of participation. On the one hand, it

represents the power and sovereignty of the state as a privileged place in which the abstract category of the state becomes concrete. On the other hand, the museum is the place where the cultural property of the state is made accessible and symbolically handed over to the public. Yet this symbolic partaking of the individual in the sovereignty of the state did not come as a mere gift. It implied for the individual the demand to act upon himself, to form and transform his behaviour. The writings of, for example, British social reformers from around the mid-nineteenth century document how the museum visit was assumed to have a positive effect on the morals of the individual citizen. Another aspect is the museum architecture, which was constructed in ways that allowed people from lower social classes to observe those of a higher social class from a secure and distanced position. As this shows, space and vision are organised in the museum not merely to allow a clear inspection of the objects exhibited, but also to allow for the visitors to be the objects of each other's inspection. What today is pointed out as a new phenomenon – the way in which museums such as Tate Modern cultivate and bring the museum to the fore as a place for a public that displays and confronts itself – has actually been a central aspect, if not *the* central aspect of this institution from its beginning. It is not only, and maybe not even primarily,

a place for the display of objects; these objects function as props, or better, as tools for a civilising ritual for the individual that serves an internalisation of control and self control.[8]

It is hard to imagine today that there were once discussions about whether or not one could let people go through the museum by themselves, uncontrolled. Yet we have to keep this larger historical context in mind in order to understand the significance of the museum within a fundamental process of transformation that signals modernity; a transformation from a central organisation and execution of power through a monarch to the individual who governs and regulates himself through norms, rules and disciplines. In the course of this internalisation of power – a process that Foucault calls 'governmentality' – the museum provided new forms and a new ritual of self-governance.

The museum, then, is not just a place where ideologies and values are represented in artworks. It is also a place where these values become part of a mental and physical experience; a place where values are acquired, embodied and therefore become effective. It is on this operational level that Höller's slides intervene in the museum display. They strive towards a subversion and reorganisation of precisely those values that the museum cultivates. Against the museum as a machine for control and rationalisation, they propose ecstasy

and euphoria. Against the self-reflected and self-controlled visitor, they produce or provoke a visitor who is ready to lose his mind and to be transformed. Thus the museum is reconfigured and yet at the same time becomes what it has always been: a place where one forms and acts upon oneself. In bringing to the fore precisely those aspects of the human being that the museum once strove to suppress, Höller on the one hand subverts everything that this institution stands for. On the other hand, this idea of operating upon experiences only continues something that has been essential to the museum from its beginnings. It has always been, first of all, a place to develop and cultivate specific techniques of the self. In the process of shaping the modern individual, the mature citizen, the museum cultivates notions of composure, sensitivity and refinement – and suppresses everything that is compulsive and dissipated. It seems that today all these aspects that were supposed to be eliminated from the individual character, can be reintroduced and reintegrated into this place. Höller's slides bring them back in – as something equally formed and formative, refined and refining to one's own personality.

1
In fact the artist himself has also mentioned that he has doubts about the term 'doubt' in relation to his work and that he uses it mainly for lack of a better word.
2
Carsten Höller in Daniel Birnbaum and Carsten Höller, Tuotanto/Production, exh. cat., Kiasma Museum of Contemporary Art, Helsinki 2000, p.10.
3
Carsten Höller in conversation with Jens Hoffmann: 'Carsten Höller: The Synchro System and You(s)', Flash Art, May/June 2001, p.131.
4
Friedrich Nietzsche, Menschliches, Allzumenschliches (1878); Human, All Too Human (1909–1913), trans. Helen Zimmern, sect.5, 'Signs of Higher and Lower Culture', para.251.
5
I have discussed elsewhere this transformative potential of art and its ontological implications in relation to the concept of performativity, as introduced by J.L. Austin (see 'To Celebrate: A Displacement of Critique', in Pierre Huyghe: Celebration Park, exh. cat., Musée d'Art Moderne de la ville de Paris and Tate Modern, London 2006, pp.126–9).
6
'Carsten Höller: The Synchro System and You(s)', p.131.
7
Jacques Rancière, The Politics of Aesthetics, London and New York 2004.
8
For an elaboration of this idea, see Tony Bennett, The Birth of the Museum, London and New York 1995.

Clockwise from below: <u>Round Slide House (1:100 Model)</u> 2000; <u>Maison Ronquières</u> 2000; <u>Atomium Slide House</u> 2003

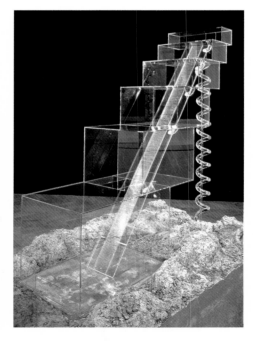

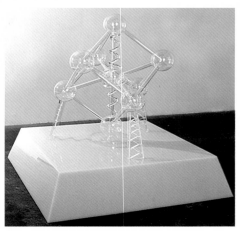

Roy
Kozlovsky
Historical
Study

A Short History of the Slide
Roy Kozlovsky

The simplicity and ubiquity of the slide suggests that it has been in use since time immemorial. Inclined surfaces such as ramps, canals and chutes have long been used to move inert matter by the force of gravity in the context of manufacturing, irrigation or transport infrastructure. Yet the construction of slides for the purpose of projecting a living human body in gravity induced motion, either for amusement or for emergency, is entirely modern. The earliest textual or pictorial accounts of a human slide predate to the late 1860s and early 1870s.[1] While seesaws and swings were already documented by Chaucer or represented in sixteenth-century painting, the slide is entirely absent from the genre that depicted children's play and popular forms of amusement. Pieter Bruegel's encyclopedic painting of children's play, Kinderspelen (Children's Games, 1560), did show a child playing on a cellar door, yet it represented the inclined surface as an instrument for climbing up rather than for sliding down (fig.11).[2]

While the lack of written or pictorial evidence does not necessarily establish that humans never built or used slides before the middle of the nineteenth century, it does suggest that only from that time the act of sliding became perceptible to discourse as a meaningful social technology. What then are the origins of the human slide, and in what context was it developed and manufactured as a mechanism for inducing pleasure and fleeing danger?

Slides and the science of motion

The emergence of the slide coincides with the birth of modern science. In Two New Sciences (1638), Galileo initiated the science of mechanics with a slide experiment that invalidated the older system of Aristotelian science, which was unfamiliar with the concept of acceleration. The slide allowed Galileo to slow down the effect of gravity on objects and render their movement measurable and quantifiable. The experiment demonstrated that falling objects, in this case bronze balls, gained velocity at a steady rate.

Galileo claimed to have repeated the experiment hundreds of times achieving the same results, validating the superiority of the modern experimental method over scholastic reliance on logic in comprehending physical reality. Following the success of Isaac Newton in reducing the motion of the physical universe to three fundamental laws, Enlightenment philosophers attempted to do the same for human thought and conduct. If for the rationalist philosopher René Descartes, the self-conscious individual subject existed independently of the world, merely by declaring

Fig.11
Pieter Bruegel the Elder, <u>Children's Games</u> 1560
(detail). Kunsthistoriches Museum, Vienna

Fig.12
'The Mechanical Joys of Coney Island', <u>Scientific
American</u>, 15 August 1908, including Luna Park's
Toboggan slide and Steeplechase Park's Hitting
the Pipe slide

'I think therefore I am', for the empiricist Thomas Hobbes writing at the same time, 'Life is but a motion.'[3] Hobbes defined both sensorial and intellectual faculties such as vision and memory as effects of motion. Ever since, man's freedom and happiness have become associated with bodily mobility. The kinetic subject would experience movement as a pleasurable sensation, taking the place of the bronze balls to glide down the inclined, measured surface of Galileo's slide. Does the metamorphosis of the slide from a scientific instrument into an amusement apparatus signify that humans have been objectified by science, or rather that science has been humanised by parodying Galileo's experiment and rendering it un-instructive?

Human slides: technological origins

It is unclear if slides for propelling humans originated in the context of ice or water technologies, in the appropriation of transportation or irrigation systems, or in winter or summer related festivities. In the English-speaking world, the first slides were called 'Human Toboggan Slides', pointing to their origin in indigenous Canadian culture.[4] In continental Europe, slides and the precursors of roller coasters were known as 'Russian Mountains', referring to their origin in the Russian public ice slides, a popular winter activity since the seventeenth

century.[5] The first US patent for an amusement slide was titled 'Artificial Sliding Mountain' (1869). Both exotic origins suggest that Western civilisation could conceive of sliding as pleasurable only after recognising it in the customs of the Other.

Yet an exploration of the exact origins of the slide is less instructive than an examination of the social conditions in which such a familiar technology could be seen in a new way and given an alternative function. The modern human slide necessitated first a subject that would experience a mechanically induced kinetic pleasure as equal, even superior to traditional pastimes based on sociability. Secondly, it depended on the emergence of public institutions and commercial enterprises that took upon themselves to provide the masses with kinetic modes of amusement: the playground and the amusement park.

Amusement parks and vertigo machines

The amusement park emerged out of the European traditions of the pleasure garden and the fairground. It supplanted the aristocratic garden culture of relaxation and socialisation in a sylvan setting, and the plebeian fairground culture of overturning everyday life, with the exhilarating and democratic experience of technology. Yet the mechanisation of leisure was predicated upon the formation of an industrial subjectivity, in which the initial shocking encounter with technologies such as the railroad and the factory could be transformed into a pleasurable sensation. For example, the roller coaster originated in switchback railway technology for transporting coal. In 1873 entrepreneurs converted a disused system in Pennsylvania into a tourist attraction by placing people in its idle coal carts, reinventing the infernal world of mining labour as a spectacle. A decade later LaMarcus Adna Thompson built the first purpose-built roller coaster in Coney Island, initiating the capital-intensive amusement-park industry.

Historians of popular culture interpret the amusement park as providing the masses an escape from the harsh conditions of industrialisation and urbanisation, into a meticulously staged world of illusion and unrestrained visceral pleasure.[6] In its lack of pretence to educate or moralise, the amusement park constituted a challenge to Victorian morality as well as to Progressive reformers who advocated more educational and useful types of leisure.[7] Yet Thompson thought that the mechanisation of leisure would redeem the masses: 'Many of the evils of society, much of the vice and crime which we deplore come from the degrading nature of amusements ... To substitute something better, something clean and wholesome and persuade men to choose it, is worthy of all endeavor.'[8] The

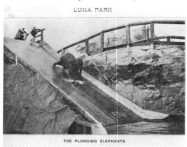

THE PLUNGING ELEPHANTS

Fig.14
L.Roziger, Amusement Device,
US patent 1,511,139, October 1924

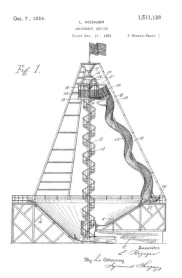

amusement park reflects the turn-of-the-century's transcendental conception of technology and suspicion of the masses: while the interaction of people with each other only multiplied their vice, the interaction with machines would purify their soul.

Slides constituted an important part of the amusement park experience. Frederic W. Thompson, the founder and planner of Luna Park (1902), incorporated slides into the opulent splendour of its spiralling architecture. Unlike the roller coaster, whose utilitarian design betrayed its industrial origin, the Coney Island slide had its escalator and lift technology concealed underneath the picturesque scenery of mountains, cascades and castles. This demonstrates what the architectural historian Sigfried Giedion derided as the tendency to cloak each new invention 'with historicizing mask'. Equating technological progress with social progress, Giedion wrote: 'New constructional possibilities were created, but at the same time they were feared; each was senselessly buried beneath stone age sets.'[9] Yet designing objects to mimic the appearance of something else rather than being 'true' to their inner essence, was in itself a novel strategy that revealed as much as it concealed: one of F. Thompson's Human Toboggan slides had two curving pathways that converged in the middle of the ride, bringing strangers into contact (see fig.12). Just before the sinuous slides

converged, a bump gave the rider an impulsive lift and fall, 'to the huge delight of the watching crowd'.[10] In <u>Delirious New York</u> (1978), the architect Rem Koolhaas identified the sexual and exhibitionistic undertones of such mechanisms in his typical deadpan manner as 'anti-alienation apparatus'.[11] Steeplechase Park had a slide designed as a smoking pipe, which was as popular with spectators as with the sliders. It displays the theatrical and voyeuristic aspect of the slide, in which spectators derived their pleasure from observing others in a state of bewilderment and ridicule. The use value of sliding became marginal to its exhibition value, as demonstrated by the popularity of Luna Park's shoot-the-chutes elephant water slide (fig.13).

In their quest to explore the potential of mechanical movement to induce 'thrills' while maintaining the strictest safety standards, amusement parks became centres of technological innovation. The <u>Scientific American</u> periodically covered the technical feats of Coney Island's pleasure machines. The next step in the evolution of kinetic amusement machines was a crossbreed of the gravity slide with the motorised centrifuge, combining the thrill of falling with the disorientation of spiralling motion (fig.14). These extravagant machines inspired play theoreticians to seek for deeper and darker explanations for the willingness of modern subjects to submit their bodies to the tantalising sensation of mechanised sliding.

The French sociologist and former Surrealist Roger Caillois attempted to theorise the meaning of these 'vertigo machines', as he termed them. He argued against scientific attempts to explain vertigo in mechanical terms as the effect of motion on the semicircular canals which function as the body's balance organ. Play was foremost a cultural activity that was irreducible to the physiology or psychology of the individual.[12] In <u>Man, Play and Games</u> (1958), Caillois classified play into the four universal categories of *agôn* (competition), *alea* (chance), *mimicry* (simulation) and *ilinx* (vertigo), the last of which is extremely suggestive for theorising the slide. He was interested in turbulent movement in its capacity to destroy momentarily the stability of perception and inflict 'a kind of voluptuous panic upon an otherwise lucid mind'.[13] According to Caillois, the ritualistic function of vertigo was to induce a trans-like state as a means for initiation into the bonds of collectivity. The transition to modern civilisation implied the gradual decline of the violent and seductive cultures of the mask and vertigo, and their substitution with the rational and constructive pairing of competition and chance. Yet according to Caillois's structural worldview, these innate impulses still had to be be provided with an outlet. Modernity

Fig.15
G.W. Packer, <u>Playground Slide</u>, US patent
2,461,345, 8 February 1949

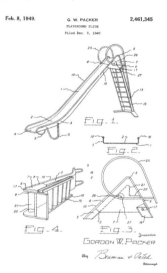

Fig.15
G.W. Packer, <u>Playground Slide</u>, US patent
2,461,345, 8 February 1949

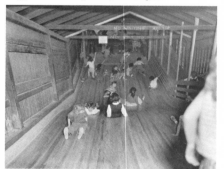

Fig.16
Giant wooden slide c.1905, Smith Memorial
Playground and Playhouse, Philadelphia

does so by mechanising vertigo and introducing it into amusement parks, fairs and playgrounds. Is the slide then a modern safety valve for pacifying turbulent and atavistic instincts inherent in human nature, or rather the opposite, an attempt to construct a new consciousness to accommodate the gyrating forces of modernity itself?

Playground slides: fear as pleasure

The modern slide is most readily associated with childhood. The question arises as to why the activity of sliding was deemed so desirableand beneficial to children that philanthropic organisations and civic authorities have been equipping playgrounds with slides for more than a century. Is it simply because children like to slide? To answer this question, it is necessary to position the slide in the context of the institution of the playground.

Playgrounds first emerge in England in the late 1860s in tandem with compulsory elementary education and the elimination of child labour. The shift from the labouring child to the schooled child gave rise to the 'problem' of the idle child, and the free time of children became the subject of policy. Moreover, with the emergence of a modern notion of a sheltered childhood, reformers became alarmed that working-class children were playing in the street, where they prematurely learned the vices of gambling, drinking

or worse. Playgrounds were constructed to separate these children from the culture of their class, as a way of 'cutting the slum mind at its roots'. But how to attract such children to the moral safety of the playground, when the street was much more entertaining? Reformers replaced the original conception of the playground as a garden where the inborn capacities of children may unfold, with the concept of the playground as a reformed amusement park. They introduced the four Ss of the playground, the swing, seesaw, sandbox and slide, to supplement the three Rs of elementary school education, reading, writing, and arithmetic, as the foundation upon which working-class children could be made into citizens.

With the exception of the sandbox, playgrounds are predicated on apparatuses that induce a repetitive, kinetic pleasure. Henry Curtis, the founder of the Playground Association of America rationalised sliding as a beneficial activity for developing 'muscle and celerity', an improvement over gymnastics, which he deemed too German and 'unnatural', thus inimical to the American spirit of play.[14] Yet not all took for granted the mechanical and repetitive type of play provided in playgrounds.

The question that occupied the turn-of-the-century child experts was why apparatuses like the slide succeeded in engaging children. Their theories contributed to the process in which play policy was naturalised as providing the population with a biologically inscribed, essential human need. Herbert Spencer explained play as an outlet mechanism for discharging surplus human energy.[15] From this perspective, the aim of the slide is to provide children with an endless loop until their youthful energy is safely spent. A different model for explaining the more dangerous aspects of sliding was provided by Karl Groos, the author of The Play of Man (1899). Working from the perspective of evolutionary biology, Groos defined play as an instinct whose function was to develop skills needed in maturity.[16] He emphasised the make-believe dimension of play, its self-reflexivity – the first time children are thrown in the air, they cry, yet from the second time onward, they laugh, since they learn to perceive the simulation of danger as a pleasurable experience. Groos's contemporary, the psychologist G. Stanley Hall, defined 'tossing, swinging, and sliding' as 'laughter excitants', which activated and discharged a biologically inherited, archaic fear of height. For Hall, laughter and pain were intertwined: 'Opposite as are our states of pleasure and pain, their expression is not so dissimilar but that in some cases of immaturity, hysteria or extreme provocation, they are confused.'[17] The affinity between pleasure and pain, and more specifically children's love for repetitive

play, led Sigmund Freud to speculate the existence of a death instinct as a counterforce to the sexual instinct in <u>Beyond the Pleasure Principle</u> (1920). Does the slide represent humanity's instinctual ambition to overcome fear, or its innate desire to self-destruct?

Slide design

Since the slide is also a material object that is manufactured, installed and serviced, theories of design and the economies of production have as much impact on its shape and design as educational and psychological theories of play.

Early slide design aimed towards efficiency of structure, assembly and use (fig.15). Its bare bones, industrial appearance betrayed a mechanical conception of children's bodies: examination of slide patents shows that its technology was borrowed from fire escape slides and industrial processes such as transporting lumber or assorting materials such as wheat, coal or ores. The slide was designed with the same functional restraint that guided the form of gym equipment, eliminating all ornament, colour and symbolism. Initial design concentrated on the mechanical performance of the slide as 'a beautiful exercise', making it both faster and safer. The most critical part was where the ladder was joined to the slide. Structurally, it had to be rigid enough

Fig.17
Slide built by children at St John's Wood adventure playground, London before 1966

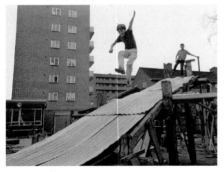

Fig. 18
Isamu Noguchi, plaster model for <u>Play Mountain</u> 1933 (unrealised). The Noguchi Museum, Long Island City, New York

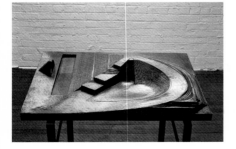

to withstand the weight and movement of the user, and ergonomically, it had to provide a safe yet frightening transition between climbing and sliding: the design of the handlebar was crucial in allowing the user to maintain equilibrium at the vertiginous moment when gazing downward triggered the fear of falling.

Playground slides were initially made of wood. Wear and tear, as well as rain and sun, weathered the surface, which had to be constantly waxed to retain its smoothness. The shift to metal slides in the 1920s reduced maintenance costs and eliminated the menace of splinters. Metal could be bent and rolled to make stronger and lighter structures, and was more resistant to destructive forms of play such as vandalism. Yet metal slides created new difficulties. In harsh climates, metal slides inflicted bruises, heat burns, and frostbites, hence the postwar shift to plastic slides (which created new problems such as static electric shocks).

While the common slide appears to be shaped by impersonal forces and rational design processes, its design is not by any means inevitable. Alternative slides just as functional were built in the early period of the playground movement, before the slide assumed its canonical shape. The giant wooden slide at Smith Playground in Philadelphia, built in 1905 and still in use, had a roof which solved the problem of weathering, allowing a year-long use of the slide

(fig.16). In contrast to the individualising experience of the common slide, it was unique in promoting a communal, shared experience of sliding. The giant slide defamiliarises the common slide and exposes its solipsistic character. By inducing children to coordinate their movement in relation to others, it manifested the democratic aspirations of early playground reformers, as formulated by Luther Gulick in 1904: 'People who play together find it easier to live together and are more loyal as well as more efficient citizens. Democracy rests on the most firm basis when a community has formed the habit of playing together.'[18]

After the Second World War, playground reformers advocating more imaginative and constructive types of play environments became disenchanted with the functional slide. This development coincided with the growing involvement of architects and artists in the design of playgrounds. Lady Allen of Hurtwood, who was both a landscape architect and a pioneer advocate of children's rights, wrote in 1946 a devastating attack on the traditional playground and its slides:

The best the Borough Engineer can do is to level the ground, surface it with asphalt, and equip it with expensive mechanical swings and slides. His paradise is a place of utter boredom for the children, and it is little wonder that they prefer the dumps of

Fig.19
Niki de Saint Phalle, <u>Golem</u>, Rabinovitch Park,
Jerusalem 1972

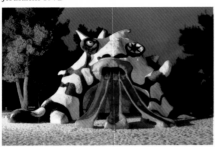

Fig.20
J.M. Kirker, <u>Fire Escape</u>, US patent 506,238,
10 October 1893

*rough wood and piles of brick and rubbish
of the bomb sites, or the dangers and
excitements of the traffic.*[19]

Allen's solution to the crisis of
the playground was to convert blitzed
property into adventure playgrounds.
Invented by the Danish landscape
architect T.H. Sørensen, an adventure
playground has no readymade play
equipment, and it is up to the children
themselves to create the playground
out of discarded junk. Yet its stress on
creativity and participation did not
exclude the pleasures of the slide. The
St John's Wood adventure playground
had a giant slide built by the children
(fig.17). It provided the playground with
a striking visual landmark, a source of
identity and pride, as well as a loving
yet critical parody of both the readymade
slide and the adjacent modernist
housing estate.

While radical planners such as
Allen relinquished their authority over
the design of the slide and handed it
to the users, the profession as a whole
interpreted the demand for imaginative
play as a licence to break away from
functionalist restraint and attune the
playground to what they assumed to
be imaginative in the eyes of the child.
Postmodern designers began to inject
the slide with narrative and identity, and
constitute the slide as a work of art rather
than a piece of recreational equipment.
The American sculptor Isamu Noguchi

was the first to tackle the playground as a sculptural landscape. His unrealised <u>Play Mountain</u> (1933) was equipped with a water slide for the summer and a snow slide for the winter, both integrated into the playground's geometric and archaic design (fig.18). Disposing of the functional ladder, Noguchi reinterpreted the ascent as a ritual rather than an exercise. His design, rejected 'with scorn' by New York's Park Commissioner Robert Moses, evoked the mythical origins of the slide in water and ice, and in the seasonal cycles of pre-industrial forms of communal leisure.

The quest to integrate the slide experience into art and endow it with narrative culminated with the work of Niki de Saint Phalle. The <u>Golem</u> slide (1972) in Jerusalem and the <u>Dragon</u> slide (1973) in Knokke-le-Zoute, Belgium, were designed as mythical creatures. Children enter the belly of the beast, and exit through its jaws on a tongue-like slide (fig.19). Saint Phalle's figurative slide reinterpreted the element of fear that was part and parcel of sliding. Rather than triggering a fear of falling, it activated an archetypal 'nightmare of being devoured'. [20]

Noguchi and Saint Phalle's work represent the site specific and symbolic approach to the slide. Yet the dominant trend in contemporary slide design is increasingly determined by standardisation and globalisation and the dominance of retail chains such as Wall Mart and Sears. The contemporary slide is manufactured as a component of a modular system. Clients can select different units from a catalogue and assemble them on site. The overall structure can be geometrical or figurative, yet what truly guides its design is the limited liability provided by the manufacturer. The association of the slide with fear has been turned upside down – it is the fear of accident and litigation that nowadays determines slide design, rather than the simulation of fear.

Emergency slides

Psychological and physiological explanations of the slide stress its simulation of danger as the source of its pleasure. Ironically, the other modern usage of the slide is for emergency escape from actual danger. Escape-slide technology came as an afterthought, to cover up the failure of architects and builders to fireproof multi-storey buildings with internal wooden structures. The emergence of fire insurance institutions and their imposition of fire codes and inspections led to the creation of a parallel fire escape industry. A boost to both was provided by a series of fires that devastated the downtowns of Chicago (1871) and Boston (1872) leading to the legislation of a national building code mandating the instalment of external means for egress in multi-storey buildings.

Early escape technology adapted

Fig.21
D.F.Youngblood, Fire Escape, US patent 1,200,686,
10 October 1916

Fig.22
Le Corbusier's Villa Savoye, Poissy 1929, interior
with ramp and spiral staircase

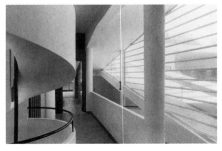

marine technology to architecture. Long aprons and tubes from sailcloth were rolled underneath windows. In the event of emergency, they were stretched and anchored to the ground. The dependency on ground support led to the development of permanent slides and ladders made of wood or steel. Promoters of escape slides argued that they were more suitable to evacuate children and women, especially since women wearing nightgowns allegedly hesitated to descend escape ladders: apparently, they feared indecent exposure more than fire. More significantly, the slide was faster.

Evoking Galileo's experiment, fire fighters tested and compared the time it took a class to evacuate a school using ladders and slides. The Boston Daily Globe reported on one such experiment in 1899: 'Before the fireman had descended two feet of the ladder 12 children had reached the ground'. [21] The advantage of the gravity slide was that it necessitated little physical effort or prior training. Yet its drawback was that it required more space than the ladder (hence the invention of the spiral slide), it provided easy and unwelcomed entrance from the street (hence the retractable and foldable slides), and most problematic of all, it had to be accessible at different levels of the building without blocking those coming from above (hence the segmented slide).

Innovations in fire escape technologies were readily incorporated

into playground and amusement park slides, but not into architecture. Two slides in particular raise this difficulty. J.M. Kirker's double helix spiral escape system (1893) combined a slide for descent and a staircase for ascent, enclosed inside a glass-domed cylinder that kept smoke and flames out, while allowing light in (fig.20). While evoking the origin of the spiral slide in an older spiral staircase technology, it also pointed to its unrealised potential as a permanent, everyday architectural fixture. D.F. Youngblood's segmented escape slide (1916) alternated between U-sectioned slides that connected each floor, and horizontal sections equipped with rollers that allowed access from each level (fig.21). It had a sprinkler system in the hollow cavity underneath the slide, rather than above it, as in proper water slides. Youngblood's escape system, in its uncanny resemblance to the iconic facade of Centre Pompidou (1976), problematises the masonry architecture to which it was attached.

The practicality and elegance of these inventions raises the question as to why slides were not assimilated into architectural discourse at the time. It is not that architecture shied away from diagonal movement: Russian avant-garde architecture employed diagonal forms to symbolise the revolution. Nor did modern architecture have any reservations about attaching functional elements to its facades. On the contrary, the architectural historian Kenneth Frampton captured the essence of functionalism as an architectural language 'in which expression resides almost entirely in processal, secondary components, such as ramps, walkways, lifts, staircases, escalators ... and garbage chutes'.[22] The difficulty rested elsewhere, in the relationship that modern architecture established between body and mind, movement and reason.

This is best demonstrated in Le Corbusier's Villa Savoye (1929), which had both a ramp and a spiral staircase, yet their incline did not allow for a sliding movement (fig.22). The building embodied Le Corbusier's concept of architectural promenade, 'offering constantly changing views, unexpected, sometimes astonishing'.[23] Only a mobile subject could experience the 'magnificent' play of solids and voids by walking through architectural space. Yet this subject was always erect and in control. Perhaps sliding was deemed too strange to be assimilated into architecture, since it positioned subjects in an awkward, compromised position, where they were too aware of their corporality, rather than their rationality. Did the relation of the slide to 'other' spaces such as the playground and the amusement park, or its association with disaster, render the slide as illegitimate, infantile or grotesque to an architectural discourse that found its legitimacy in reason?

Architecture, moreover, is about the triumphal act of ascent rather than descent, which is the proper domain of cinema and literature. The mythical dimension of the slide has often been explored in cinema. In films such as Star Wars (1977), Being John Malkovich (1999), or The Matrix (1999), the lead characters find themselves slides and chutes that descend into waste bins, or into another person's consciousness. The cinematic slide recreates the Futuristic myth of technological baptism,[24] perhaps also re-enacting the primal moment of birth, following Otto Rank's theory of the birth trauma as the source of human anxiety. As in literature, the cinematic fall puts into doubt our stable conceptions of reality and the self, only to recover them by descending into the murkiness of the unconscious.

While the architectural profession hesitated in legitimising the slide for everyday use, the aircraft industry fully endorsed it as a standard safety component. In the early period of commercial air travel, ladders and canvas sheets were used to evacuate aeroplanes. These required the crew to exit first and hold out the chute for the passengers. Larger jet aircrafts necessitated a more rapid, impersonal and deskilled form of evacuation, which took into consideration the unpredictable dynamics of crowd behaviour. In the 1950s, the American company Air Cruisers developed the escape slide out of its inflatable life-vest technology.[25] To escape, passengers need only remove their high heels. Perhaps the unexpected yet familiar, even comical sight of a colourful inflatable slide offsets the immobilising impact of fear, inducing the passengers to jump by recalling a shared childhood experience.

Conclusion

The humble slide resonates with modernity precisely because its simplicity and lack of destination opens it to so many contradictory modes of signification and interpretation. In the playground, it is associated with the kinetic-repetition complex, set in opposition to the disciplinary space of the school and the moral impurity of the street. In the amusement park, the slide is associated with the thrills and follies of amusement rides, as a counter experience to a regimented, industrialised and urbanised modernity, though employing similar technologies and strategies. In the context of safety technology, slides abandon the body to the force of gravity in order to rescue subjects from their dependency on gravity-defying technologies such as the high-rise and the aeroplane. In the context of the museum, the slide becomes a thought experiment: by subjecting our bodies to an entirely other yet familiar sensorial regime, it redefines the relation between art and sensation, technology and pleasure, movement and liberation.

And in the context of architecture, slides may be readily assimilated into the discourse of sustainable development as a pollution-free, eco-friendly mode of transportation. Equipping shopping centres, subway stations or office buildings with slides to replace mechanical escalators for downward movement is not only a practical way of saving energy: it signifies that environmentalism needn't be austere or bucolic. Rather, by appropriating a century old technology of kinetic amusement as a legitimate, even desirable mode of transportation, the slide may herald a new era of sociability based on uninhibited yet responsible modes of collective pleasure, at once down to earth and out of this world.

1
Josef Strutt's exhaustive survey The Sports and Pastimes of the People of England (1801) did not account for slides, although it did describe a board game called Slide Thrift. Josef Strutt, The Sports and Pastimes of the People of England, London 1903, pp.243–4.
2
The art historian Edward Snow established that Bruegel contrasted this activity with that of climbing a tree. Edward Snow, Inside Bruegel: The Play of Images in Children's Games, New York 1997, pp.85–6.
3
Thomas Hobbes, Leviathan, London 1985, p.81.
4
According to the Oxford English Dictionary, the English explorer George Warburton was the first to document the use of slides for amusement rather than transportation, in 1846.
5
Judith A. Adams, The American Amusement Park Industry: A History of Technology and Thrills, Boston 1991, p.13.
6
In the words of Judith Adams, it provided 'a release from the swelling pressures of crowded, dingy urban areas as well as increasing mechanized and regimented industrial work.' Adams 1991, p.41.
7
Amusement parks were 'more vigorous, exuberant, daring, sensual, uninhibited, and irreverent', and challenged the dominant elite culture and its stress of discipline, self-control and character building. John F. Kasson, Amusing the Million: Coney Island at the Turn of the Century, New York 1978, p.6.
8
Adams 1991, p.16.
9
Sigfried Giedeon, Building in France, Building in Iron, Building in Ferro-Concrete, Santa Monica, California 1995, p.85.
10
'The Mechanical Joys of Coney Island', Scientific American, 15 August 1908, p.110.
11
Rem Koolhaas, Delirious New York, New York 1992, p.36.
12
'The study of the functioning of the semicircular canals is an inadequate explanation of the vogue of swings, toboggans, skiing, and the vertigo-inducing rides at amusement parks.' Roger Caillois, Man, Play and Games, Urbana, Illinois 2001, p.170.
13
Caillois 2001, p.23.
14
William A. Gleason, The Leisure Ethic: Work and Play in American Literature, 1840–1940, Palo Alto, California 1999, p.5.
15
Walter D. Wood, Children's Play and its Place in Education, London 1915, p.13.

16
*Reversing the relation between childhood and play,
Groos claimed 'Children do not play because they are
young, but are young in order that they may play.'
Wood 1915, p.23.*
17
*G. Stanley Hall and Artur Allin, 'The Psychology of
Tickling, Laughing and the Comic', American Journal
of Psychology, October 1897, p.6.*
18
*Dominick Cavallo, Muscles and Morals: Organized
Playgrounds and Urban Reform, 1880–1920,
Philadelphia 1981, p.37.*
19
*Lady Allen of Hurtwood, 'Why Not Use Our Bomb
Sites Like This?' Picture Post, 16 November 1946, p.26.*
20
*Carla Schulz Hoffman (ed.), Niki de Saint Phalle:
My Art, My Dreams, Munich 2003, p.16.*
21
*'Something New in Fire Escapes in Boston', Boston
Daily Globe, 20 August 1899, p.21.*
22
*Kenneth Frampton, Modern Architecture: A Critical
History, London 1992, pp.9–10.*
23
*Quoted in Beatriz Colomina, Privacy and Publicity:
Modern Architecture as Mass Media, Cambridge,
Mass. 1996, p.6.*
24
*Marinetti's 1909 Futurist Manifesto begins with a
car crashing into 'a maternal ditch, brimming with
muddy water – O factory drain! I gulped down your
nourishing mud and remembered the black breasts
of my Sudanese nurse.' Quoted in Reyner Banham,
Theory and Design in the First Machine Age,
Cambridge, Mass. 1980, p.102.*
25
*The first patent for an inflatable escape slide was
awarded in 1956. The first aeroplanes equipped
with slides (in 1959) were Boeing 707 and DC-8.
Information courtesy of John F. Hendricksen of
Air Cruisers.*

General Public Agency Feasibility Study

Slides in the Public Realm
A Feasibility Study for London

GENERAL PUBLIC AGENCY
with Adams Kara Taylor

August 2006

Contents

1 Introduction

In our increasingly corporate public realm and risk-averse culture, the idea of slides as public transportation allows examination of many pertinent issues. Is there space for vision within our current planning and regeneration context? Where does pleasure find a place for expression in public life?

General Public Agency is a regeneration consultancy specialising in social, spatial and cultural planning with particular emphasis on the public realm. We were delighted to be invited to produce this feasibility study for Carsten Höller. His idea for exploiting slides as transportation within the public realm brilliantly addresses many of the concerns and issues that we grapple with in considering identity, play and accessibility in public space.

Our interest in these issues sprang from an unexpected research finding. In 2000 the directors of GPA produced a major programme at the Architecture Foundation entitled *Calling London*, which invited 2000 multi-disciplinary practitioners to respond to a brief: a vision for a future London. The responses were presented by leading architects, artists, planners, academics and writers within a 10-day programme of performances, lectures, screenings and workshops. The theme that emerged across the presentations was not an expected one of tall buildings, transportation, or density, but that of play and pleasure. These leading thinkers observed that play as a spontaneous, non-age specific activity is being designed out of city life. This concern was expressed across all disciplines and has fundamentally informed our work.

The brief from Carsten Höller, to investigate the feasibility of slides within the public realm, has allowed us to test out the policy context, the technical issues and the potential value of using slides in the public realm. Our choice of a site, Stratford in East London, was informed by the search for a certain quality of everyday-ness coupled with a desire to consider the slides as interventions within an area experiencing major regeneration.

2. Aim and scope of study

This study is a response to a brief set by the artist Carsten Höller to explore the feasibility of using slides within the public realm of London. The core principle provided for us by Höller, acting as our client, was that slides are, or could be, a beneficial and practical addition to the life and fabric of the city. The aim of this study therefore is to investigate the design, legislative and technical feasibility of this concept.

A balance has been sought between pushing the technical, physical, imaginative and spatial potentials of slides with a rigorous examination of real world solutions, constraints, and opportunities.

The study falls into 2 sections: a general feasibility study of slides within the current urban planning context (Section 3); and a detailed feasibility within a given site: Stratford in East London (Section 4).

Technical scope
Wiegand, designers and manufacturers of slides provided us with technical advice. Their extensive experience of creating slides for theme parks and playgrounds, using efficient standardised components, offered an established system, already tested by Carsten Höller, with which to approach the subject.

General Public Agency collaborated closely with **Adams Kara Taylor** for assistance on the structural design of the slide proposals, and the **IJP Corporation** for mathematical modelling.

Potential uses of slides in London's public realm

Integrating and enhancing existing transportation, replacing railway tracks

The Docklands Light Railway, with its undulating track layout, raised or submerged stations, and complex relationships with surrounding buildings, could accept slides with very little effort. Here, slides would rationalise connections and act as rail alternatives.

Revealing or amplifying changes in level

A slide following the existing pedestrian staircase within Holborn Viaduct, providing rapid transfer from the main road between the City and the West End, to Farringdon Street below.

Connecting related institutions

A primary school, a secondary school and a further education college are sited close to each other near underused Paddington Green. Slides provide easy access to the Green from each institution, creating a new meeting point and shared space whilst retaining its public function.

Collective descent

A cluster of slides, enhancing the circulation systems of the Lloyds of London building, which houses many insurance underwriters who operate separately yet collectively.

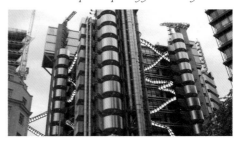

3. Policy context

"London's streets should be performing a variety of functions. They should provide a safe and pleasant means of travelling...and act as a network of attractive public spaces in which people can meet and enjoy life... places for pleasurable collective enjoyment" (London Plan, p.193)

A. The concept of pleasure in policy

A key feature of slides is that they are fun. The concept of pleasure in planning policy is rarely tested. This is partly due to its subjectivity as a concept. All policy guidance now tends to state that 'good design' makes more successful places, but this is a vague term at best. 'Attractive' is another word often used and 'enjoyable' appears in the quotation above but rarely elsewhere. 'Pleasant' is used sometimes but does not convey the euphoric fun that slides provide.

Fun and risk are closely allied – it is no coincidence that our bodies produce adrenaline both when we have fun and when we are in danger. Places that are fun can potentially cause accidents; people affected by increased adrenaline, serotonin or endorphin levels may fail to notice the hazards around them or the hazard that they present to others.

However, the current governmental focus on design, and on creating a sense of identity, can be used to justify public slides. People like to be in spaces that they enjoy; and with people comes money, jobs, increased house prices and all the symptoms of regeneration. Slides fit well into this 'place-making' agenda and could be used to contribute to a marketable identity.

It may be that one of the most powerful arguments in favour of slides is that they provide an everyday way for people to smile and laugh. The Commission for Architecture and the Built Environment (CABE) and the government are now promoting design that encourages healthy lifestyles as antidotes to problems of obesity, respiratory conditions and stress, but the contribution of pleasure in the built environment towards physical and mental health has barely been touched upon. The benefits of laughter and smiling include a reduction in the risk of heart

Increasing access to waterways

A brick retaining wall separates a pavement from the towpath on the Regents Canal in Hackney. Slides break through to provide access. At under 3 metres, these slides need not be fully enclosed and so would not provide hiding places.

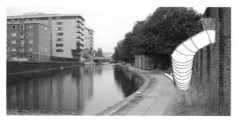

From a private place to a public place

Running from the hallway of a small flat in a post–war residential dwelling, and terminating outside a greengrocer on the permanently busy Edgware Road. An intimate slide.

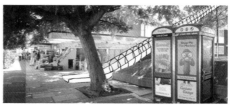

Sewing together old and new

A mutual understanding between commercial office space and a 19th century Baptist church allows a descent from the higher levels of each involving passage through the other.

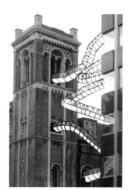

Enhancing access to private and public gardens

Residents, companies, and educational institutions share the gardens of Bedford Square. Each would gain their own private access route, re–establishing a central outdoor meeting place for these distinct 'residents.'

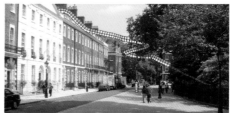

attacks, lower stress levels, and improved production of antibodies. It is estimated that 12.8m working days are lost to stress, depression and anxiety each year. In the same way as environments that make walking pleasurable mean that people take more exercise, environments that make people smile or laugh without them having to actively choose to partake in an 'activity' will benefit the nation's health and economy.

B. Regulatory framework

The feasibility of slides for public use must be tested against national and local policy and legislation. Current relevant legislation and guidance includes **planning policy** (covering siting, visual appearance, integration into context, access and sustainability guidance), **building regulations** (structural and environmental performance, connection to buildings, disabled access, fire escape and safety), and **health and safety legislation** (safety to persons in construction and usage, risks to public safety, maintenance).

Slides can serve a number of functions, each of which presents its own challenges. Within or between buildings, the building regulations will be the key driver of feasibility. Slides are only currently covered by legislation relevant to playgrounds and amusement parks, which is principally a matter of health and safety as building regulations do not cover constructions that are not buildings. If slides are in the public realm, planning, access and disability, and health and safety become important. Negotiations with local authorities will be necessary, and issues of vandalism, sabotage, maintenance and risk will be major considerations in the design. If however they are for purely private use, a different level of risk may be acceptable.

It may be debated whether slides are a form of **assisted walking** (like escalators or underpasses) or **public transport** (like buses or monorails). Slides are similar to miniature underpasses or overpasses in that they bypass obstructive physical barriers and are self-contained, with clearly defined entrances/exits and no possibility of leaving the route at any other point. Current best practice discourages underpasses and overpasses in favour of ground-level movement – PPG13

Connecting departments (incorporating junctions)

The Foreign & Commonwealth office and HM Treasury face each other across King Charles Street, Whitehall. A slide equipped with a 'junction' or set of points carries individuals between departments or to a different floor.

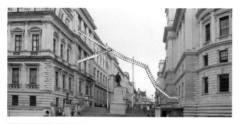

Alleviating ground floor pedestrian flow

Oxford Circus is an intersection which is perpetually overcrowded, serving both the individual in a hurry and also the meandering shopper or tourist. A slide here navigates through the crowds from the London College of Fashion, to the ticket hall of the underground station.

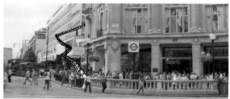

Animating underused public spaces

The shops and restaurants of King Square are popular but the square itself never feels busy or dynamic. Slides from various levels of the residential buildings above, and terminating in the square itself, provide dynamism, character, and animation to the public realm.

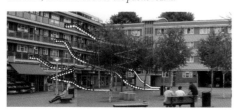

Employing appropriate existing façades & infrastructure

These windows incorporate a perfect semi-circle which would fit, almost exactly, current slide components. A reinterpretation of neglected building details.

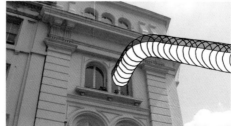

(Planning Policy Guidance 13: Transport) requires plans to *"avoid long detours and waiting times, indirect footbridges or underpasses"*. Slides may be seen to mitigate against long detours, though they do present challenges of enclosure similar to underpasses. Slides could also be classified as public transport, due to the distance that they can cover, the potential for mechanical assistance (as in the 'maglev' slide in section 4), and the fact that they depart and arrive at specifically defined 'stops'.

Regardless of this categorisation, all new forms of public transport or streetscape must comply with access and disability legislation. All policy contains statements to this effect; for example, the London Plan requires that *"Boroughs should adopt the following principles of inclusive design that will require that developments: can be used easily by as many people as possible without undue effort, separation or special treatment"*. Slides do not provide equality of access to the elderly or disabled sections of the population which means that they can only be an additional means of movement; lift or ramp access will still be required, and stairs will also be necessary for fire reasons if the slide is in an enclosed space. Whether a disabled-friendly slide could be designed could be tested – a slide which takes 'trolleys' may potentially achieve this and become more feasible in terms of access legislation.

Slides are potentially carbon-neutral in operation. They may be most relevant for relatively long-distance, shallow gradient travel in place of a shuttle bus or moving walkway, or a long walk. PPG13 states that *"Quick, easy and safe interchange is essential to integration between different modes of transport"* as demonstrated in the proposed slide between the two stations at Stratford. In this case slides would provide a more direct and sustainable mode of transport (for the able-bodied) than alternatives.

C. Conclusion
Issues of disability provision and health and safety are important legislative cordons which cannot be ignored. In the current planning context slides can only be one of many modes of transport. If they succeed in creating a sense of place and a happy, healthy urban landscape, there may be sufficient rationale to promote them as an integral and useful part of the public realm, re-introducing pleasure to the urban fabric.

Creating new rituals

The journey from Portcullis House and its governmental offices to the floor of the House of Commons is a regular one made by Members of Parliament. Arrival in the House by slide would create a new ritual.

Going where pedestrians cannot go

Behind tall structures on main roads often lie less tall service buildings and extensions. Here slides bridge impassable spaces and make light of the complexity and messiness of the existing environment.

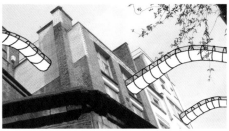

Enhancing the end of a working day

At the end of the working day, the commuter flow across the Thames from the City of London to London Bridge station is relentless. A slide from one of the riverside offices to the bridge itself, travelling over the river, would allow a few of these travellers an enhanced and speedier journey home.

Managing the process of change

Elephant and Castle's existing provision for pedestrians is disorientating, and it will see dramatic changes in coming years. Slides placed within the existing urban fabric and yet following the emerging rules of future masterplans could provide constancy through this difficult change.

4 Detailed feasibility study: Stratford Town Centre

To investigate the feasibility of slides within the urban fabric we selected a particular location in which to test value and challenges. Stratford in East London was chosen due to its generic qualities of 'everytown' combined with a position at the heart of a major programme of regeneration.

Stratford is undergoing massive change over the coming decade as part of the sweeping regeneration of East London due to the Olympics and the Thames Gateway growth strategy. Stratford is to become the major metropolitan centre in East London and a

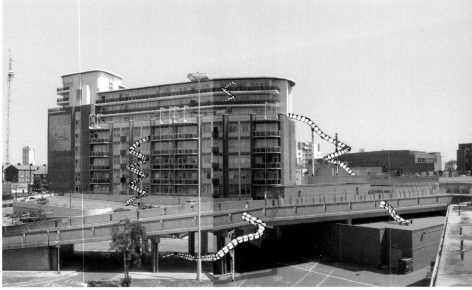

European business quarter due to the decision to site a new Eurostar station on its disused rail lands. The new station will be surrounded by a new metropolitan area, 'Stratford City', providing 30,000 new jobs and 4,500 new homes. This will also act as the Olympic Village for the 2012 games.

Stratford has a rich hidden history but lacks a strong positive identity at present. New development in the area has so far lacked a distinctive local character and has not responded to the culture and character of its communities. In this situation, slides could be a way to give the area a new focus and identity that could engage the local communities and provide a uniquely different public realm.

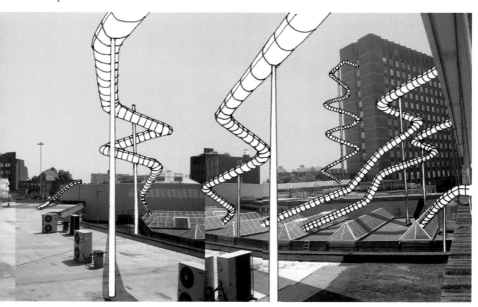

4.1 Planning context

In the mid-19th century, the Great Eastern railway established depots and workshops covering 78 acres and built a 'new town' alongside. Stratford has been an important junction of road and rail since then. Currently the borough of Newham, of which Stratford is a part, is the fourth most deprived in London, has the lowest life expectancy, and is also the most ethnically diverse in the UK. The council hopes that Stratford's regeneration will give local communities access to greater opportunities for jobs, education and an active life, whilst celebrating its existing identity.

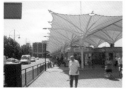

Stratford today is largely the product of massive change in the 1970s, when the centre of the town was redeveloped as a covered shopping centre, with office space and a multi-storey car park above. The shopping centre is at the heart of the town, and forms most of its major pedestrian arteries - unusually, it remains open as a thoroughfare even when shops are closed. Pedestrian flow outside the shopping centre is dominated by traffic and some public spaces feel dead or empty. It is hard to navigate easily and to get a coherent sense of the whole area. A thriving market exists within the mall and on its eastern flanks.

The recent focus on Stratford's regeneration has seen major new residential development in the area, and house prices have risen dramatically. The 'arts quarter', centred upon the refurbished Theatre Royal, had been upgraded with a cinema, performing arts venue, and public realm improvements. Though dominated by retail use, the centre of Stratford is characterised by an overlapping of functions, uses, and users. Its role as a public transport hub and a lively 'arts quarter' ensures that the area is bustling.

The Stratford City development will shift Stratford's 'centre' to the north-west, focused upon the transport interchange. Integration of the new quarter with the existing town and local communities is a key issue. Stratford City will include significant affordable housing and social infrastructure but is physically separated by major roads and rail lines, which may discourage new residents from using the cultural and shopping facilities in the existing centre. A land bridge is planned to connect the two areas, but the link between the new international station and the existing regional station (a 400m distance) originally intended to be provided by a travelator, is now open to question and may rely upon a connection provided by an extension to the DLR.

4.2 Slides in Stratford

The locations identified for slides in Stratford aimed to test different uses and physical conditions while suggesting the contribution that slides could make to the wider regeneration and identity issues in the area. Four different conditions have been explored to demonstrate the different potential forms and uses, ranging from a long-distance shallow slide to steep slides, and varying degrees of public use.

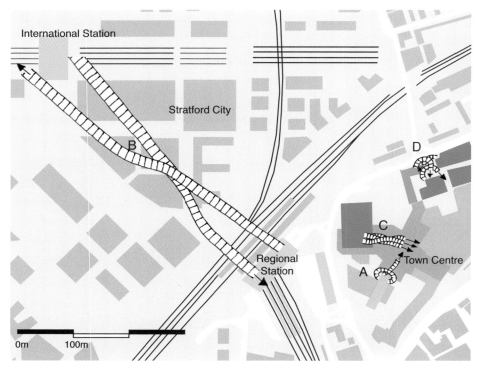

A. Office slide
Connecting two adjacent locations which are vastly different in height.

From: Tall office tower adjacent to shopping centre
To: Southern mall of shopping centre, ground level

B. Station slides
Exploring the viability of slides over great distances, taking into account the constraints and opportunites imposed by mass public usage.

Between: The existing Stratford regional station and the new
 international station (minimum distance 400m)

C. Shopping slides
Exploring the implications of public usage from various levels converging on one destination point.

From: Various levels of the multistorey car park
To: The main mall/atrium of the shopping centre

D. Theatre slides
Exploring the potential of slides to enhance the wider context in which they are located.

From: A reconditioned residential building
To: 'Gerry Raffles Square', the open air focal point of the 'arts
 quarter' of Stratford. A second slide provides an exit route
 from the theatre to the square.

A. Office slide

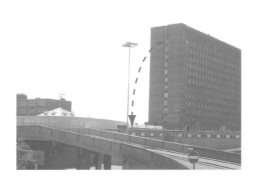 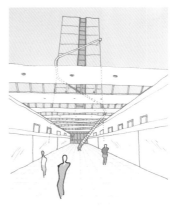

How can we address the speed and access implications of connecting two adjacent locations with a large height difference?

Morgan House is the tallest building in the area, and has an entrance lobby accessed directly from the mall. The slide could provide an alternative exit route into the mall for the office worker at lunch time or at the end of the day.

The slide must enter the mall safely and conveniently: it cannot be dangerously fast or unnecessarily long. However, we do like fast slides. Could a slide of this gradient reach a high terminal velocity and have time to slow down for a safe arrival?

A solution is to use an approximately spiral form of varying diameter, which regulates speed. In the diagrams opposite, hotter colours indicate faster speeds. Like a spring, a slide in this form could be almost structurally independent, avoiding the clutter of too much structural support at ground level.

Speed is a function of the inclination of the slide; the surface material of the slide; the material your seat is made of and the frequency of turns:

$v = f\ (\theta,\ \mu slide,\ \mu seat,\ \tau)$

where:
v = speed on slide m/s
f = function of...
θ = angle of inclination rads
μslide = coefficient of friction of slide surface
μseat = coefficient of friction of seat material
τ = turn frequency

Statement of Feasibility
This slide has an exclusive user group but a clear offer to the user. The difficult physical constraints imposed upon the proposal, and their solution here, prove the technical feasibility of slides in similarly extreme vertical situations.

B. Station slides

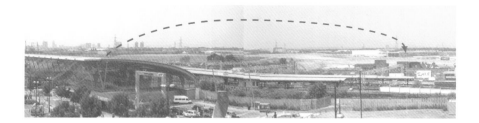

Can the speed advantage of slides remain over a long distance?

The two stations are roughly 500m apart, for which a conventional slide would need a tower of a minimum 300m high in order to go the distance, which would be unfeasible. The idea of splitting the journey into several shorter slides (and therefore several towers) was rejected. The use of motorised trolleys and wind pressure were rejected as they were considered too distant from the 'pure' experience of sliding.

Instead, a 'maglev' principle, involving a magnetic mat or sock on which the user would sit, was selected as the best technical solution for a long, shallow slide. This would involve a 'track' of magnets in the slide wall with alternating polarities, which repel or attract other magnets contained within the mat, thus propelling it at high speed. The user would barely be aware of the technological assistance, except for the need to be securely fastened to the mat.

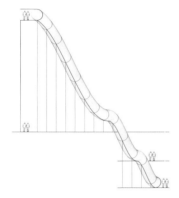

$$fDcos(p,j) := \left(1 + \frac{segment_height(p)}{2}\right) \cdot cos\left[(\cdots - shift(p)) \cdot \frac{(j-i_begin(p))}{segment_length(p)} + shift(p)\right] - \frac{cos_height(p)}{2}$$

$$fD(p,j) := \left(\frac{segment_height(p)}{2} \cdot fDcos(p,j) + height_begin(p)\right) - \frac{segment_height(p)}{2}$$

$$DeformFunc3_{i,j} := \begin{vmatrix} fD(1,j) & \text{if } 0 <= j <= 150 \\ fD(2,j) & \text{if } 150 <= j <= 210 \\ fD(1,j) & \text{otherwise} \end{vmatrix}$$

Maglev assistance would only be necessary at certain points along the journey. The geometry of the slide would slow people down by itself through its 'wave' form (above). This design solution reduces the total height to 30m, of which it is proposed that 20m is above ground, with a 10m section below ground to connect to the level of the train tracks. A separate slide for luggage, with the same geometry and modifed maglev technology, would ensure that person and their baggage arrive simultaneously.

Statement of Feasibility
The solution offered here suggests that slides are a feasible form of travel between relatively distant locations, if the principle of sliding is modified through the use of technology.

C. Shopping slides

What happens when many slides descend together and arrive in one place?

Slides could be used as an alternative to lift and stair access to enliven the experience of using everyday structures such as car parks and provide quicker access to other levels. In this study, a slide departs from each level of the existing stair and lift core in the car park. The slides would thus be integrated with the existing circulation, ensuring they are a visible 'choice'.

There are three constraints to these slides: the point of departure (ideally as close as possible to the existing stair and lift) the point of puncture of the shopping centre roof (which must be in the public areas rather than inside a retail unit) and the point of arrival (which must not disrupt existing circulation.)

The slides therefore are required to form a cluster which presents technical and design constraints However, cost savings would be made on the structure as the cluster could be self-stiffening and share vertical supports.

Parametric modelling was used to investigate the most efficient system for the cluster. By using a slight variation in the point of departure on each floor (right) rather than rigid vertical stacking, the other constraints can more easily be met.

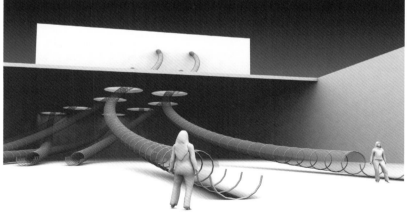

Statement of Feasibility
This is a feasible alternative to existing access in this situation. It raises issues and solutions regarding the consequences of multiple slides upon wider space usage and circulation.

D. Theatre slides

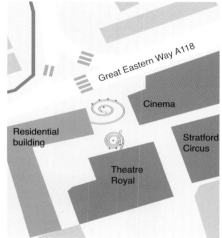

What contribution can slides make to the wider public realm?

The principal slide provides residents of the tower building with a privileged means of access to the arts quarter. A secondary slide provides an exit route from the theatre.

Gerry Raffles Square, where the slides land, has been landscaped to provide a focal point for the developing arts quarter, and also functions as a northern gateway to the town centre. However, next to a busy road, and with buildings that do not always encourage activity at ground level, the square could offer more to an active public realm.

The form of the slides could be used to enhance the square by providing a sense of enclosure away from the busy main road, and by animating the ground level, providing a sense of identity to a somewhat anonymous place.

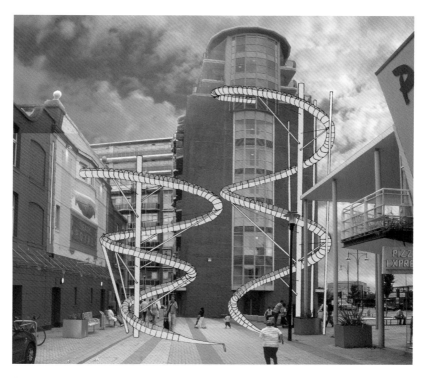

Statement of Feasibility

The proposal provides the benefits of slides as a means of transportation and enhances the quality of the wider public realm. If slides are carefully and contextually sited, and allied to broader concerns about the quality, usability, and capacity for play of public spaces they offer potential value to the physical qualities and animation of the public realm.

4.3 Health and safety, maintenance

In isolation and as play equipment, slides involve very little risk. As transportation and within the broader public realm, however, issues arise which need to be carefully considered to support wide adoption. Risks include users hiding inside slides, attempting to jump out, leaving dangerous objects inside the slide that could hurt other users, cleanliness and ventilation.

Timing and passenger volume
The safest way to cope with high volumes of people is to only allow one individual in the slide at any one time - the method used in recreational water slides. For short journeys, this remains the best option. If a slide is to travel over a greater distance and time however, it is desirable to achieve higher capacity through having more than one person in the slide at any one time. This is possible if timings are calculated to make it impossible for a person to catch up their predecessor.

Human supervision may be unnecessary if technological solutions are used. A system using motion and heat detectors along the slide's length would act against 'catch-up', deliberate or accidental blockage, and would also provide security as and when the slide is closed. Turnstiles or one-way gates at each end would prevent users entering the bottom of the slide, or descending before it is safe to do so.

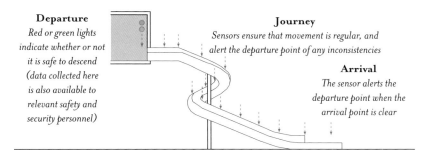

Departure
Red or green lights indicate whether or not it is safe to descend (data collected here is also available to relevant safety and security personnel)

Journey
Sensors ensure that movement is regular, and alert the departure point of any inconsistencies

Arrival
The sensor alerts the departure point when the arrival point is clear

A pleasant journey

Slides could suffer the same hygiene problems as public lifts, toilets or stairwells. Users would be unwilling to enter a slide if they could not perceive its whole length or be confident of its cleanliness. Durable mats or 'socks' could lessen this problem by preventing an individual's clothes or body touching the slide, and would protect against sharp objects left inside. These mats would require collecting at the end of each day or the development of a system of automatic cleaning and return to the beginning of the slide. This could be powered through energy generated by the friction of sliding.

Ventilation

Lengthy slides in open-air situations present issues of ventilation and overheating which would require further investigation. Long enclosed slides would be susceptible to extreme solar heat gain, particularly when shallow (as in the station slides). Solutions could include shading devices or the use of meshes that allow air flow but do not permit users to jump out of the slide or throw things down. If meshes were used, consideration of protection from rain and wind might mean that further layers would be required that could automatically close in inclement weather conditions, or a design of ventilation panels that were protected from rain.

Maintenance

A regime for the cleaning and maintenance of the slides would need to be developed in greater detail. Long slides would be especially susceptible to vandalism and high user volumes would result in a residue on the inside of the slide. Options could include an internal abseiling system or an abrasive cleaning brush or ball of the diameter of the slide which could be pushed down. An automatic cleaning system could be linked to the motion and heat monitoring to ensure that the slide was cleaned after a given number of user journeys, or at a specified time interval.

4.4 Financial feasibility

The 'theatre' slides proposed have been costed on a preliminary basis by the manufacturers, assuming the use of standard components, and a hot-galvanised supporting structure, a necessary measure for slides built externally.

Slide from residential block (90m length)	£152,000-182,000
Slide from the theatre (72m length)	£120,000-146,000
Total cost	**£272,000-328,000**
Mid-range cost estimate for two slides	**£300,000**

Both slides are significantly taller and longer than any previously built by the manufacturer, making it difficult to cost them accurately. It is likely that the final cost would be greater than the figures quoted above as construction costs rise with greater heights.

It is possible to build an ambitious bespoke playground for under £150,000. With this in mind, these slides could be seen as extravagant, but this does not take into account their practical value for residents and theatre-goers and the fact that the enjoyment and thrill they provide is not restricted by age. As they would contribute a great deal to the public realm, their cost can be judged against alternative improvements. In the UK, an architectural re-landscaping of pedestrian squares can cost up to £500 per m². The cost of the slides averaged out over area of the square would be around £300 per m². This investment would create a unique urban environment for less cost than other high quality public realm projects within the UK.

5 Conclusion

Slides offer an injection of pleasure and adrenaline into the everyday experience of the city - an aspect of urban design that is not addressed by current practice and guidance. They could contribute to the creation of a distinctive local identity within new developments but also areas that, like Stratford, have seen their character eroded by unsympathetic development. This 'place-making' agenda is currently a subject of intense debate, yet few such creative approaches have been considered.

This study has established the technical feasibility of slides to take on forms that are bigger and more complex than previously imagined. The first stage economic analysis presents a convincing picture of value with regard to cost and benefit on public realm. Further design development would clearly be necessary before implementation, but the main challenge is likely to be gaining statutory approvals regarding planning issues, safety and suitability for public use. Initially smaller slides, such as the theatre slides, may be more feasible as they would have clearer ownership and management by a committed organisation, and would act in addition to conventional means of movement.

Slides do not fit neatly into preconceived notions of what public spaces contain. Their adoption would require a committed and experimental approach from a developer and local authority to creating a new form of public realm. This would challenge assumptions about risk-aversion in favour of a cityscape that offers free fun to all ages and sectors of society. It would also question whether the provision of such unadulterated fun would encourage a more respectful attitude towards the slides than the vandalism that most public realm 'improvements' attract.

We would like to imagine a London where sliding could add smiles to the daily commute and where play was encouraged, rather than banned, from our public spaces. Creativity and spontaneity add to civic life and slides offer a practical solution to achieve this aim.

GENERAL PUBLIC AGENCY

10 Stoney Street | London | SE1 9AD
T: +44 (0)20 7378 8365
F: +44 (0)20 7378 8366
mail@generalpublicagency.com
www.generalpublicagency.com

General Public Agency would like to thank Adams Kara Taylor for their invaluable assistance. We would also like to thank IJP Corporation and Josef Wiegand & Co. GmbH for their support through technical expertise.

Foreign Office Architects Case Study

Brief by Carsten Höller

Hypothetical Slide House

A house with the outer and inner walls built partially or exclusively out of slides. The slides can be entered from the spaces created between them and used for transportation of people to a lower level of the house or a place outside the house, on the ground level. While people move up in the house on conventional stairs and elevators, the layout of the house should encourage most downward movement to be done using the slides.

The slides may either be built on top of each other, to form the walls of the building, or the space between the slides may be bridged by windows or other materials. Depending on the requirements for the space surrounded by the slides, the latter may be transparent throughout, or have a transparent upper half and a stainless steel lower half, or be executed in stainless steel only. The materials (transparent or steel) can be combined in the different parts of one slide if this slide is part of the wall structure of spaces serving different purposes.

The house is a multi-purpose building consisting of 22 floors above ground that provides for office, business and private space. The three top floors are privately owned penthouses. Floors 19 and 18 are also privately owned, but are divided into five apartments. Floors 15 – 17 are a hotel including an indoor swimming pool with a large opening to the outside and a restaurant. Pool, restaurant and the lobby of the hotel are all on floor level 15.

The ground floor of the building has a restaurant/bar in the middle of a large central lobby; the walls of this lobby are made of all the indoor slides which go down to the ground floor and which end one next to the other in one large circle or oval. All outdoor slides also end jointly at a place adjacent to the building.

Every slide connects only from one point to another; there are no dividing or otherwise multiple slides. Thus, most slides depart from the top part of the building, as the higher levels need to connect with most or all of the lower levels. All levels need to be connected except the following: 19 and 18 are not connected with 20 – 22; 16 and 17 are not connected with 18 – 22 and have only slides connecting to 15. Thus, to give an example, floor 22 has a minimum of 17 slides departing from there connecting to levels 21, 20, and 15 – 1, plus the slides connecting to the ground outside the house. Depending on the architectural requirements (many) more than one slide can connect one level to another. On levels 19 and 18 each of the five appartments needs its own range of departing slides.

The privacy in the privately owned spaces and the office spaces may be disturbed by people using the slides on their way down, as the transparent parts of the slides could allow for a look into an appartment or an office. The speed of sliding will be so fast however as to prevent any 'second look', and since there is no stopping for the users of the slides anything that might have been seen cannot be verified.

The slides should all have slopes between 30 and 35° to prevent people from being able to stop their trajectory and hence causing accidents. If required the slope can be increased for a maximum length of 2 m up to 60°. Not more than 4 m in a straight line are allowed as the increased friction in the curve is essential to keep speed levels in a safe range. The diameter of all slides should be 80 cm.

HYPOTHETICAL SLIDE HOUSE

The history of tall buildings has primarily revolved around the optimization of issues of construction and circulation. While structural explorations have aimed to minimize material needed to grow tall, circulation design has attempted to optimize the stair and lift layout to minimize the floor area taken up by the circulation which mostly amounts to half the floor area. Core design has become so efficient, that it has also become a very rigid form of knowledge. There is very little room to experiment with alternative modes of living or working within a tall building without undermining the efficiency of core layout. Try suggesting any deviation from what the 'market' pays for, what 'flow analysis' recommends in terms of numbers of stairs and lifts and you soon find out that all a designer does in core design is to endlessly play with the various elements in the core, to pinch a small area away from the core, to free up the plan by millimetres.

Carsten Höller's vision of using slides as a primary means of circulation is an exciting possibility as it offers a new start – to do away completely with stair; lifts are to be used to travel upwards while slides would be the means of access downwards as well as the escape system for the building.

Whereas lifts are a shared system of circulation in a building, slides are exclusive as they can only make a direct connection across two levels. This implies a higher degree of freedom and privacy to the towers but at the same time a redundancy of material as the total volume of slide tubes are considerably in excess of a lift. The design challenge for us was to turn this redundancy into a new economy.

The slides are arranged on the perimeter as in the Tower of Babylon freeing up the plan of circulation. This allows the redundancy of slides to be turned into an exo-skeleton, a diagonal structural lattice around the form. Like in conventional cores this plays with the synergy between structure and circulation, however, exploited on the outer perimeter it becomes a key visual instrument to the from. The mesh of criss-crossing slides creates a sinuous sensation, turning the movement through the building into the main affect of the form.

The study here shows our thought process and the discussions we held with Höller. A number of smaller investigations branched out of the decision of placing the core on the exterior rather than interior of the building. These included the branching of the form at the upper and lower areas to provide the plan with increased levels of natural light and to produce areas of programmatic specialization that avoided over densification of slides on the exterior and therefore an unmanageable skin in terms of levels of transparency. Diagrammatic studies proved that three branches to the form would allow us to produce a more or less even distribution of slides around the building perimeter even though the total number of slides was increasing towards the base of the building as the base connected every programme to the ground. The resulting tripod form defines a semi-covered open space that could be a public agora or space where other towers could connect and grow this system further.

In the Slide House, you move diagonally through the building height and see out of the building. Vertical circulation is turned into an urban spectacle while you feel gravity as part of the very experience of living and working in a multi-storey building while your body travels in space.

slide connections

SLIDES AS THE BUILDING SKIN

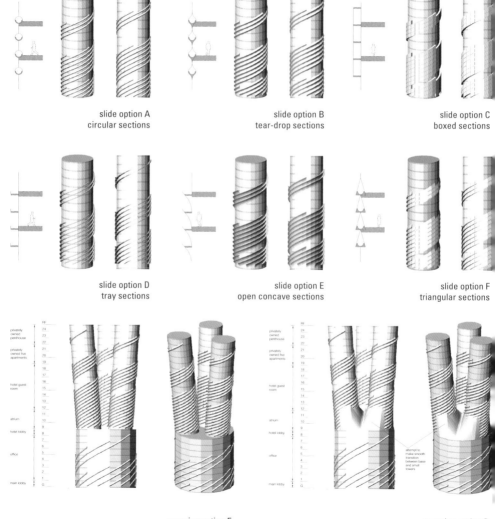

slide option A
circular sections

slide option B
tear-drop sections

slide option C
boxed sections

slide option D
tray sections

slide option E
open concave sections

slide option F
triangular sections

massing option E

massing option B

STACKING VERSUS WEAVING OF SLIDES AROUND PERIMETER

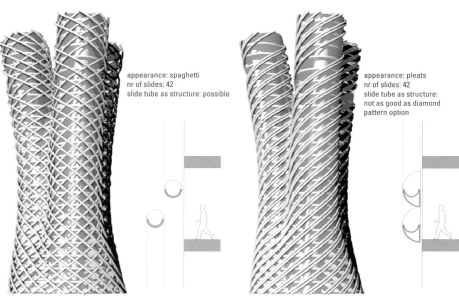

appearance: spaghetti
nr of slides: 42
slide tube as structure: possible

appearance: pleats
nr of slides: 42
slide tube as structure:
not as good as diamond
pattern option

Diamond Pattern

Diagonal Pattern

Initial studies involved diagrammatic studies of the required slide connections, using the perimeter as the space for circulation. Various assemblage as well as sections to the slide tube were considered to determine the opportunities that the tubes would offer beyond circulation: as an enclosure to the interior, as an exoskeleton to the form, in producing different visual effects to the exterior. Crossing the slides diagonally rather than stacking them emerged as the efficient structural solution as it could act as a structural lattice.

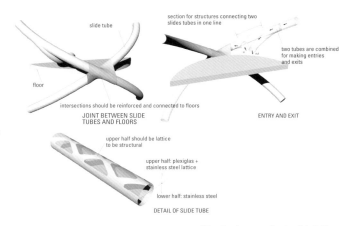

slide tube

section for structures connecting two
slides tubes in one line

two tubes are combined
for making entries
and exits

floor

intersections should be reinforced and connected to floors

JOINT BETWEEN SLIDE
TUBES AND FLOORS

ENTRY AND EXIT

upper half should be lattice
to be structural

upper half: plexiglas +
stainless steel lattice

lower half: stainless steel

DETAIL OF SLIDE TUBE

Structural connection to slide lattice

SLIDE CONNECTIONS

slide connections between floors

combined slide connections onto façade

As each program is individually connected to the ground, the lattice of slides becomes increasingly dense towards the base of the building. Though this offers increased stiffness to the lattice structurally, it has adverse effects on the interiors as they receive less natural light and views to the outside. We began therefore to explore a system where the form of the lattice would branch not only at the top but also towards the base in order to distribute the slides rather than concentrate them at the base, decreasing the density of slides along the lower parts of the volume.

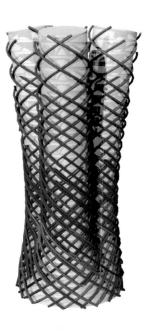

slides as differentiated lattice

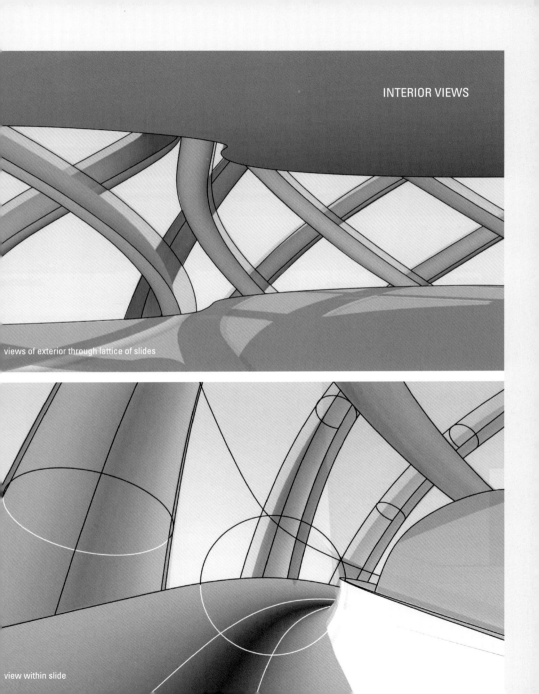

views of exterior through lattice of slides

view within slide

ALTERNATIVE BUILDING GEOMETRIES

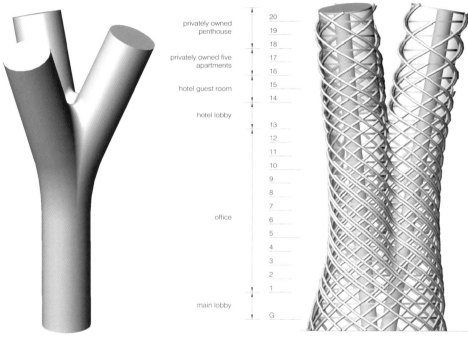

privately owned penthouse	20
	19
	18
privately owned five apartments	17
	16
	15
hotel guest room	14
hotel lobby	13
	12
	11
	10
	9
	8
	7
office	6
	5
	4
	3
	2
	1
main lobby	G

upper branching form

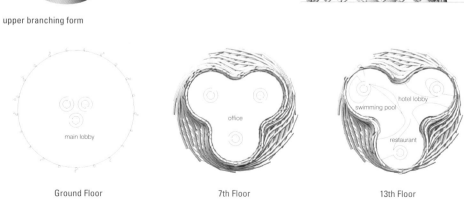

main lobby

office

hotel lobby
swimming pool
restaurant

Ground Floor

7th Floor

13th Floor

upper branched option: differing levels of privacy

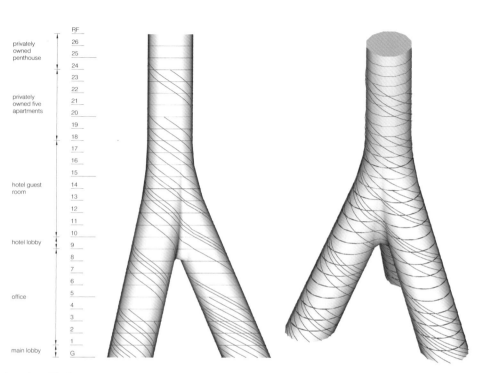

	RF
privately owned penthouse	26
	25
	24
	23
	22
privately owned five apartments	21
	20
	19
	18
	17
	16
	15
hotel guest room	14
	13
	12
	11
	10
hotel lobby	9
	8
	7
	6
office	5
	4
	3
	2
	1
main lobby	G

lower branching form

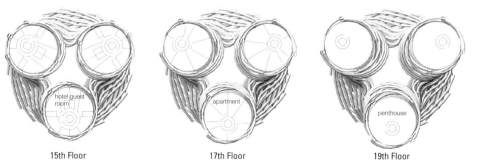

15th Floor 17th Floor 19th Floor

ALTERNATIVE BRANCHING GEOMETRIES

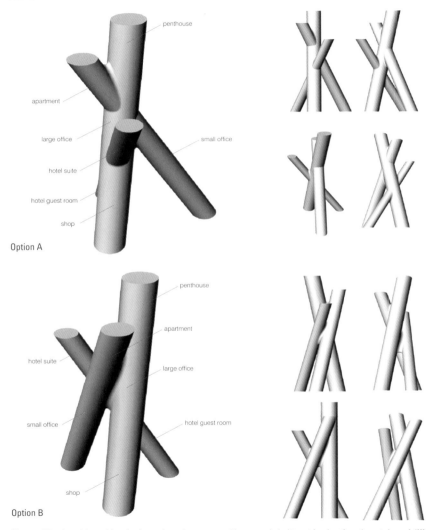

Option A

penthouse

apartment

large office

small office

hotel suite

hotel guest room

shop

Option B

penthouse

apartment

hotel suite

large office

small office

hotel guest room

shop

The combination of branching the form along the upper and lower ends led to a tripod option: three tubes of different diameters that would cater for different types of program. Zone of intersection produces larger floor plates while other zones provide discrete smaller floor areas that minimize the perimeter area around each floor and allow for more direct conenctions to the floors below.

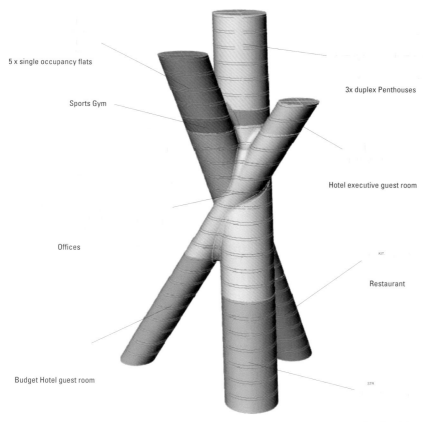

5 x single occupancy flats

Sports Gym

3x duplex Penthouses

Hotel executive guest room

Offices

KIT.

Restaurant

Budget Hotel guest room

STR

Department store

The resulting organisation offers a prototype for a 23 floor building that can accommodate multiple uses, larger floors for larger and more communal uses and smaller floor plates for more private uses. This particular case consists of 23 floors above ground that provides for office, business and private space. The six top floors host three units of privately owned penthouses. Each unit consists of two levels. The four top floors host also four units of privately owned appartments. Each unit consists of one level. The three top floors host in addition three suite rooms for a hotel. Each unit consists of one level. 16th floor is a sports gym. 15th floor is a canteen for office. 14th – 8th floors are office working space (one part of 9th and 8th floor is a hotel). 7th – 1st floors host shops. A restaurant with a bar is located on top between 7th – 1st floors. Standard hotel guest rooms are provided between 9th – 1st floors. The ground floors are lobbies with double height; the walls of this lobby are made of all the indoor slides which go down to the ground floor and which end one next to the other in one large circle or oval. All outdoor slides also end jointly at a place adjacent to the building. The roof has an outdoor swimming pool.

STRUCTURE OF A TRIPOD ARRANGEMENT

Why should the towers be inclined?

Why does each tower have a different inclination?

1) 3 towers of thin proportion.

2) The towers lean against eachother to gain stability from horizontal forces such as the wind.

3) The 3 towers have different diameters in order to provide for different programmes. This difference in diameters causes the shift of the centre of gravity. It is necessary to make the centre of gravity coincide with the centre of rigidity therefore L1<L2<L3, to optimize the ratios of L1:L2:L3 and optimize the inclinations.

The following conditions are assumed:
-The centre of gravity is (0,0). The intersection of the towers is above this centre of gravity.
-Axis 1, 2, and 3 are assumed, which are at 120 degrees from each other around the centre of gravity.
-Tower 1 is 15m away from (0,0) on axis 1.
-Tower 2 is on axis 2.
-Tower 3 is on axis 3.

Based on these conditions, the locations of tower 2 and 3 are defined according to the table below and fig.1.

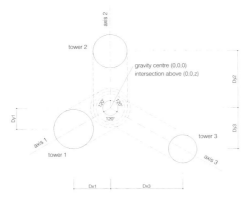

	D (m)	A (m²)	Dx (m)	Dy (m)	Sx (m³)	Sy (m³)
tower 1	14.00	153.94	-12.990	-7.500	-1999.66	-1154.54
tower 2	12.00	113.10	0.000	20.417	0.00	2309.08
tower 3	10.00	78.54	25.460	-14.700	1999.66	-1154.54
total of Sx and Sy = X and Y of the gravity centre					0.00	0.00

D: diameter of tower A: floor area of tower
Dx: X distance from (0,0) Dy: Y distance from (0,0.)
Sx: geometric moment of area for X direction = A × Dx
Sy: geometric moment of area for Y direction = A × Dy

fig.1

At what height should the towers intersect?

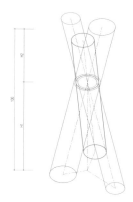

4) For programmatic reasons the upper ends of the towers branch. Considering the bending moments of the towers against horizontal forces such as the wind the best height for the intersection is determined, which has similar ability to 2).

In order to find the optimum height for the intersection, uniformly-distributed horizontal load is assumed

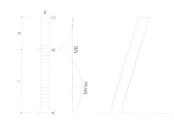

The height for the intersection is calculated as follows.

$Mmax = Ra \times X_0 - w \times X_0^2 / 2$

$X_0 = (l^2 - a^2) / 2l$

$Ra = w \times (l^2 - a^2) / 2l$

$MB = w \times a^2 / 2$

$a + l = 100$ (total height is 100m)

In the case of Mmax = MB, a and l are optimized.

$a = 29.289$

$l = 70.711$

How tall should each tower be?

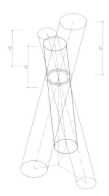

5) The length above the intersection is adjusted in order to equalize the deformation of the towers.

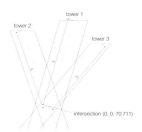

tower 1
tower 2
tower 3
intersection (0, 0, 70.711)

Deformation of tower 1 above the intersection is calculated as follows.

$\delta_1 = wl_1^4 / 8EI_1 = 105.99$
 $l_1 = 29.289$ (length of tower 1 above the intersection based on 4))
 $I_1 = \pi (D_1^4 - (D_1 - 2t)^4) / 64 = \pi \times (14^4 - (14 - 2)^4) / 64 = 867.86$
 (2m depth around the perimeter works as structure)
 $w = 1, E = 1, t = 1$

Length of tower 2 above the intersection is calculated as follows.

$l_2 = \sqrt[4]{\delta_2 \times 8EI_2 / w} = 25.855$
 $I_2 = \pi (D_2^4 - (D_2 - 2t)^4) / 64 = \pi \times (12^4 - (12 - 2)^4) / 64 = 527.00$
 $w = 1, E = 1, t = 1, \delta_2 = \delta_1 = 105.99$

Length of tower 3 above the intersection is calculated as follows.

$l_3 = \sqrt[4]{\delta_3 \times 8EI_3 / w} = 22.265$
 $I_3 = \pi (D_3^4 - (D_3 - 2t)^4) / 64 = \pi \times (10^4 - (10 - 2)^4) / 64 = 289.81$
 $w = 1, E = 1, t = 1, \delta_3 = \delta_1 = 105.99$

LIFT CORE STUDY

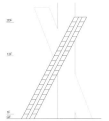

Option A - central lift

'ring' space around core

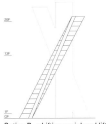

Option B - shifting peripheral lift

open plan and 'ring' space

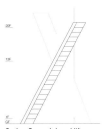

Option C - peripheral lift

free open plan

A

B

C

Option D - central lift

'ring' space around core

Option E - shifting peripheral lift

open plan and 'ring' space

Option F - peripheral lift

open plan

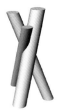

D

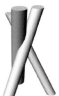

E

F

14

SYNERGIES BETWEEN SLIDE LATTICE and GLASS ENCLOSURE

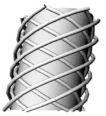

Glazing independent of slides

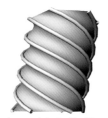

Glazing consistent with slide profile

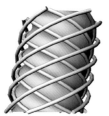

One layer of glazing consistent and another inconsistent with slide profile

Curved glass

option A - parallel slides

option B - woven slides

Faceted glass

option E - parallel slides

option F - woven slides

Glass in rounded diamond pleats

option I - parallel slides

option J - woven slides

SLIDE CONNECTION DIAGRAM

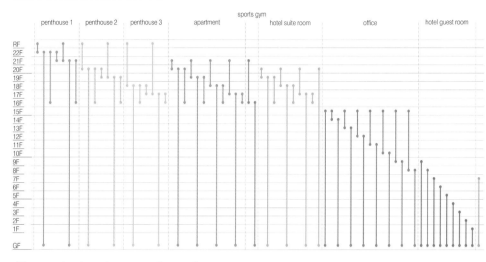

slide connections for each programme between floors

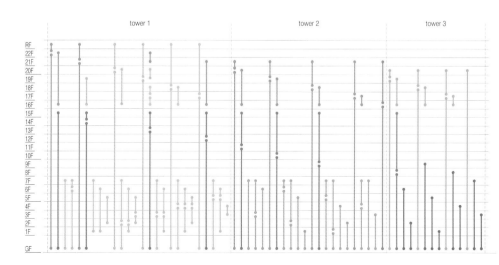

composite slide system

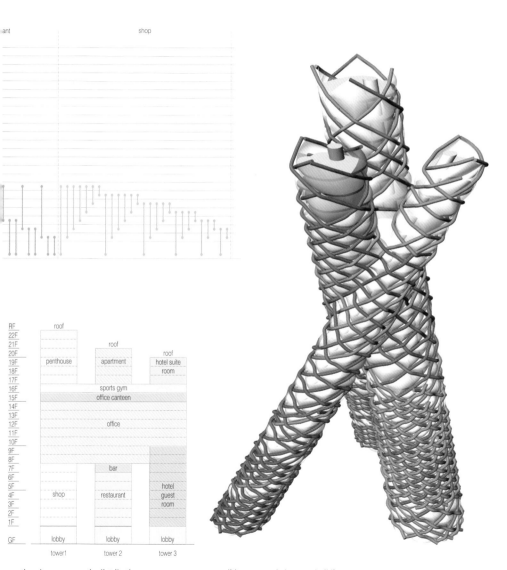

ant

shop

	tower1	tower 2	tower 3
RF	roof		
22F			
21F		roof	
20F			roof
19F	penthouse	apartment	hotel suite
18F			room
17F			
16F		sports gym	
15F		office canteen	
14F			
13F			
12F		office	
11F			
10F			
9F			
8F			
7F		bar	
6F			
5F			hotel
4F	shop	restaurant	guest
3F			room
2F			
1F			
GF	lobby	lobby	lobby

sectional programmatic distribution

slides as exoskeleton to building

17

PLANS

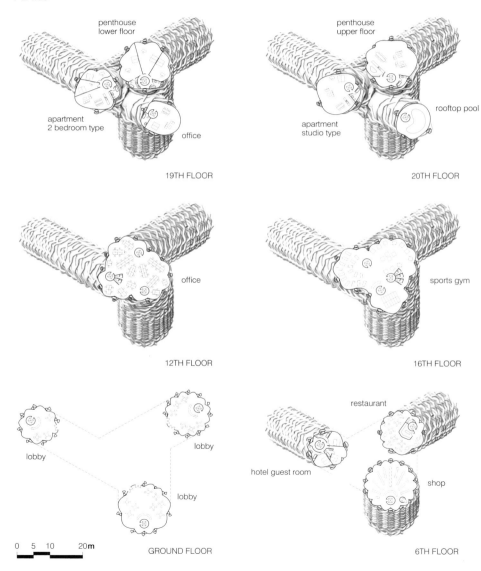

penthouse
lower floor

penthouse
upper floor

rooftop pool

apartment
2 bedroom type

apartment
studio type

office

19TH FLOOR

20TH FLOOR

office

sports gym

12TH FLOOR

16TH FLOOR

lobby

lobby

lobby

restaurant

hotel guest room

shop

0 5 10 20m

GROUND FLOOR

6TH FLOOR

RF	+96.00
22F	+92.00
21F	+88.00
20F	+84.00
19F	+80.00
18F	+76.00
17F	+72.00
16F	+68.00
15F	+64.00
14F	+60.00
13F	+56.00
12F	+52.00
11F	+48.00
10F	+44.00
9F	+40.00
8F	+36.00
7F	+32.00
6F	+28.00
5F	+24.00
4F	+20.00
3F	+16.00
2F	+12.00
1F	+ 8.00
GF	+ 0.00

0 5 10 20 m

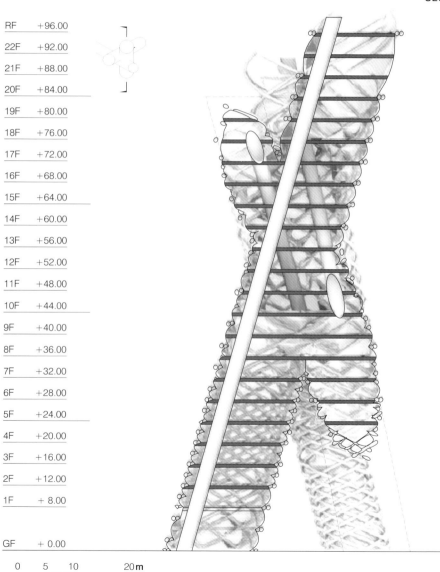

ELEVATION

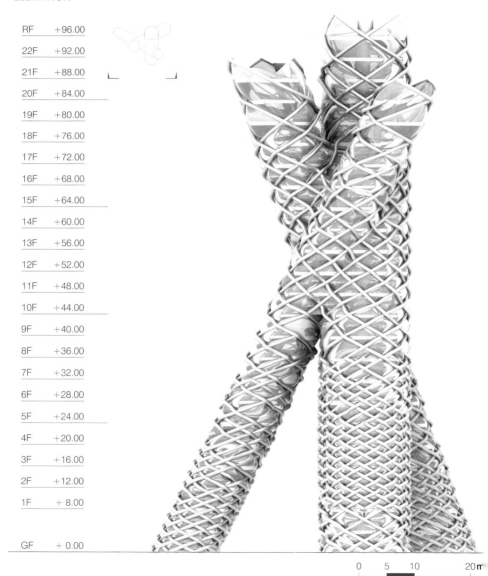

RF	+96.00
22F	+92.00
21F	+88.00
20F	+84.00
19F	+80.00
18F	+76.00
17F	+72.00
16F	+68.00
15F	+64.00
14F	+60.00
13F	+56.00
12F	+52.00
11F	+48.00
10F	+44.00
9F	+40.00
8F	+36.00
7F	+32.00
6F	+28.00
5F	+24.00
4F	+20.00
3F	+16.00
2F	+12.00
1F	+ 8.00
GF	+ 0.00

0 5 10 20m

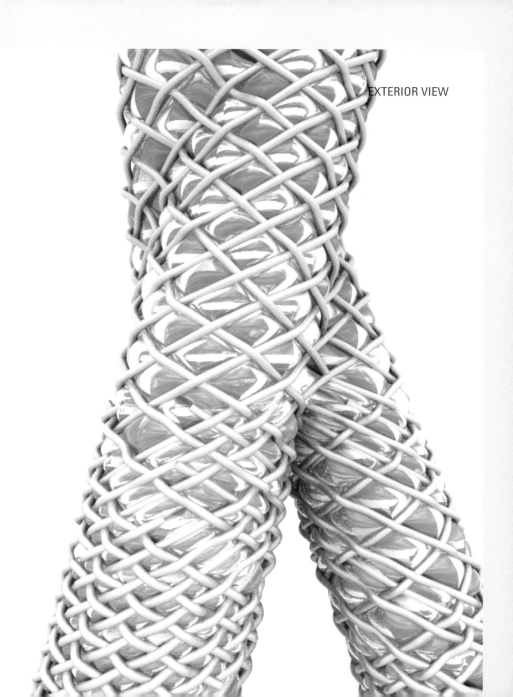

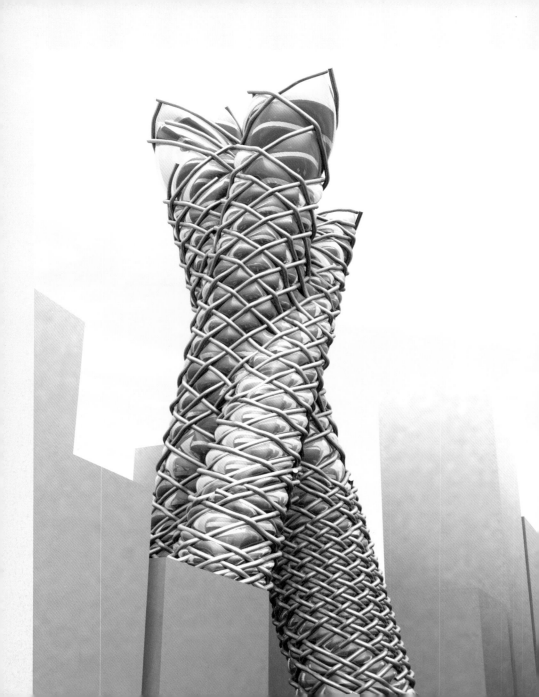

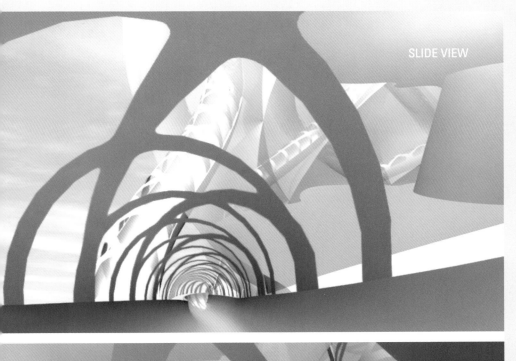
SLIDE VIEW
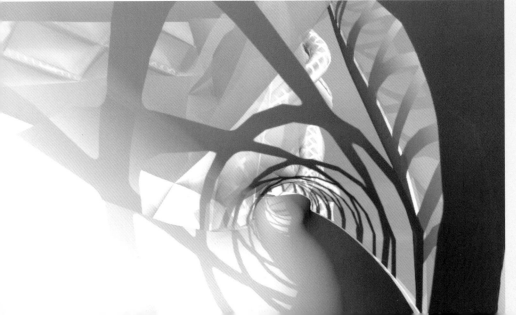

INTERIOR VIEW

Sports Gym

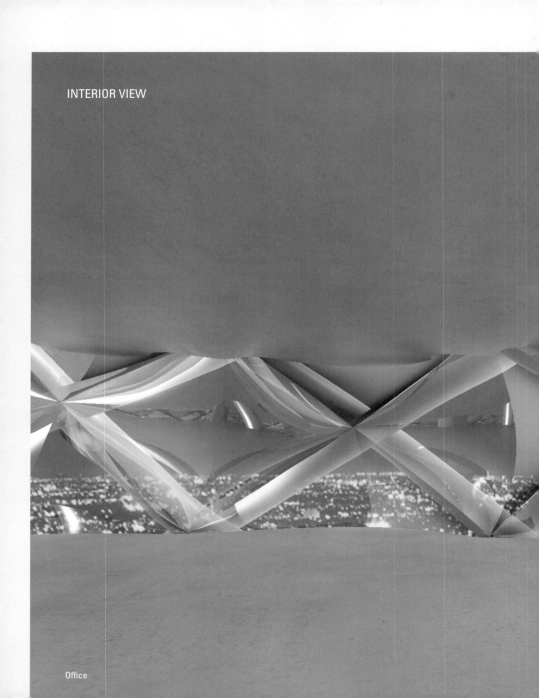

INTERIOR VIEW

Office

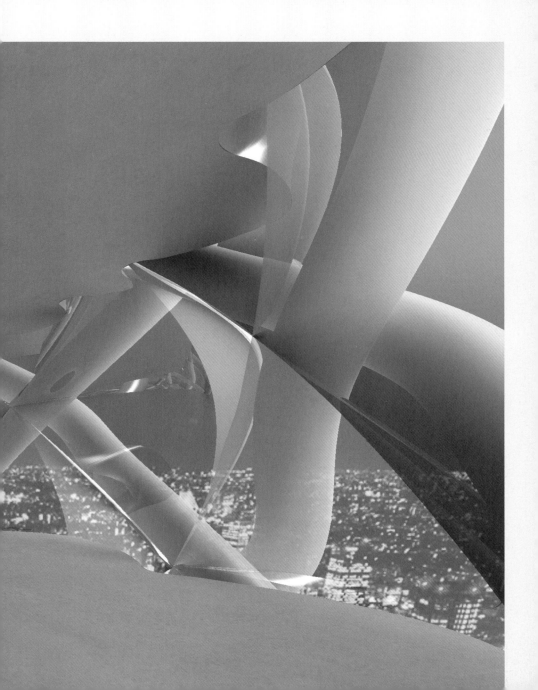

FOA Foreign Office Architects

55 Curtain Road | London EC2A 3PT | UK
T: +44 20 7033 9800 | F: +44 20 7033 9801
E: info@f-o-a.net | W. www.f-o-a.net

Foreign Office Architects would like to thank Kenichi Matsuzawa and
Taro Yokoyama at *LOW FAT structure* for their invaluable contribution.

Test Site Installation Images

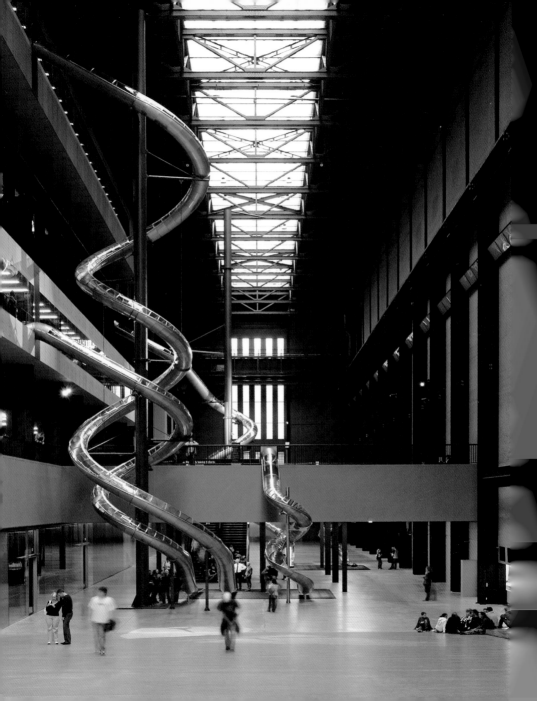

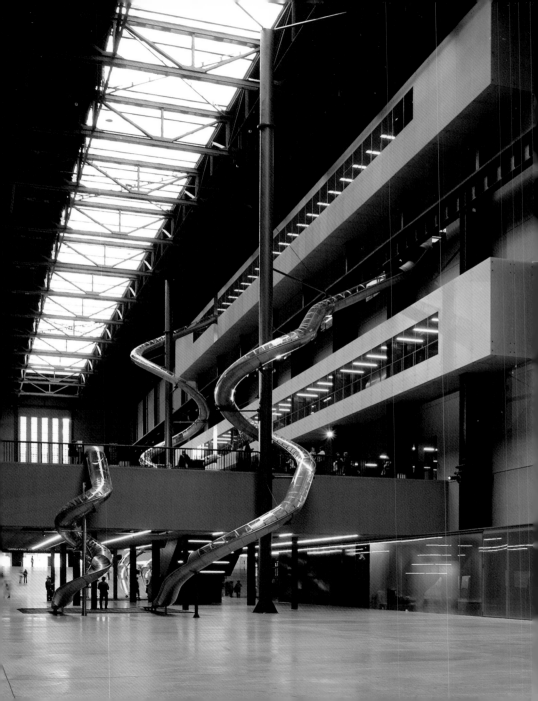

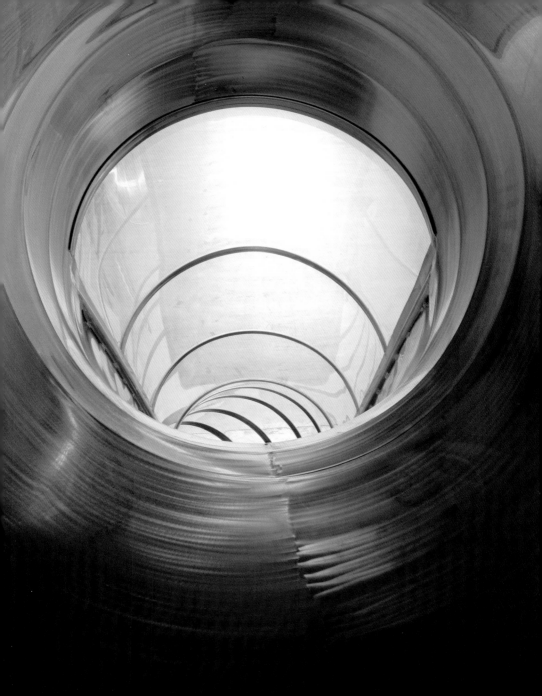

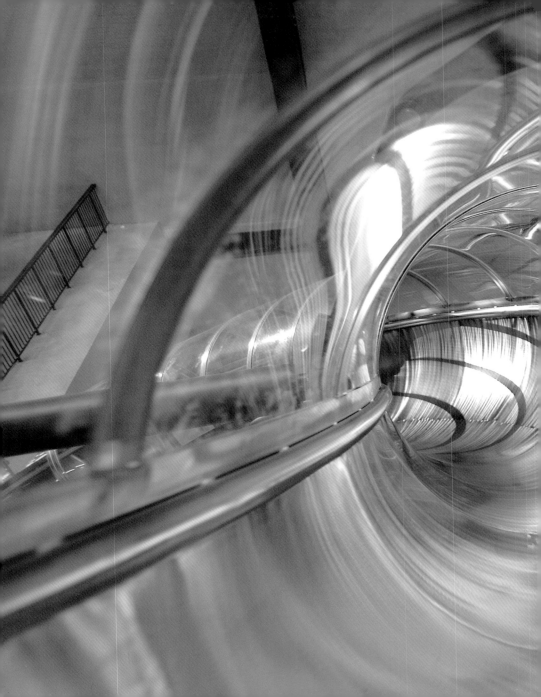

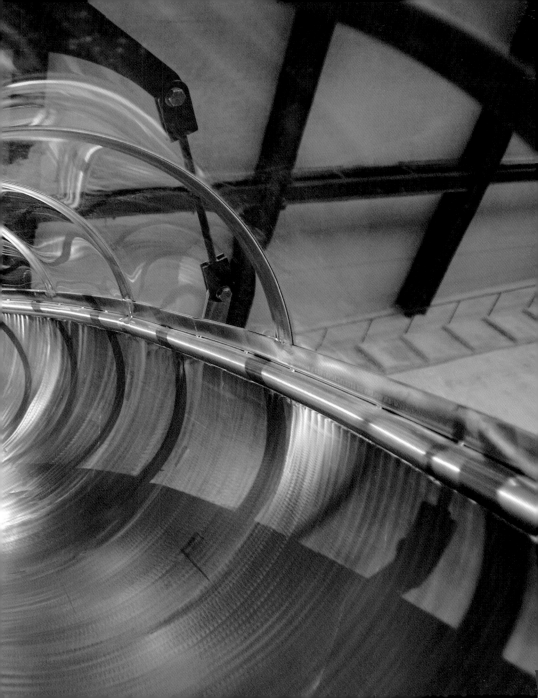

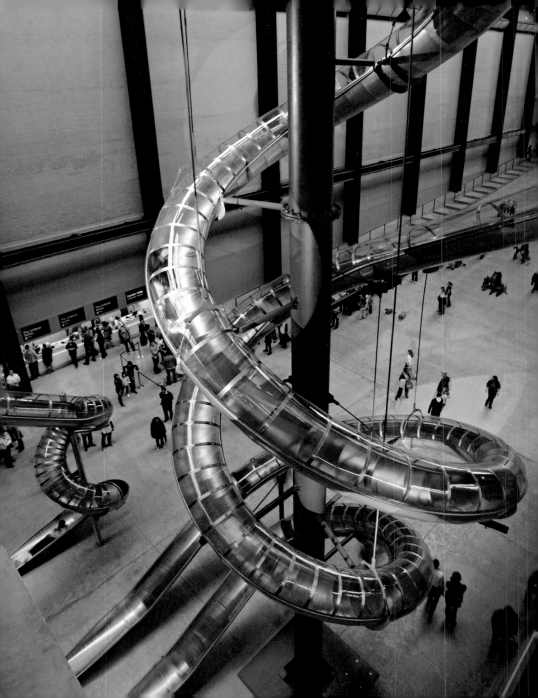

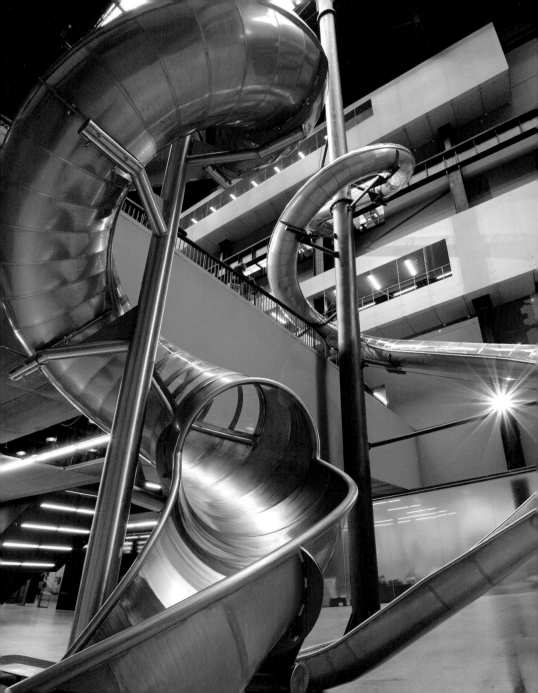

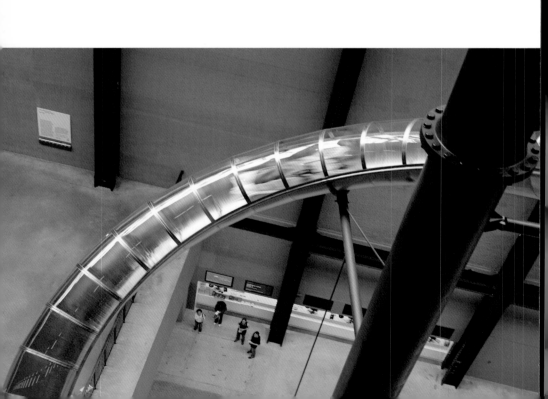

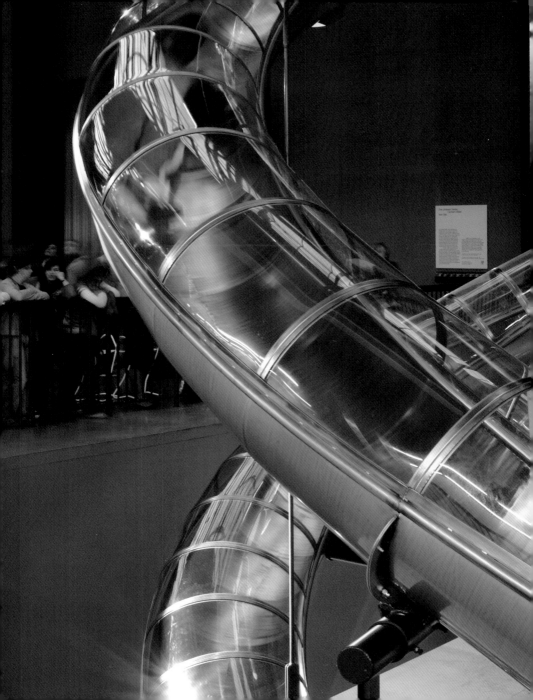

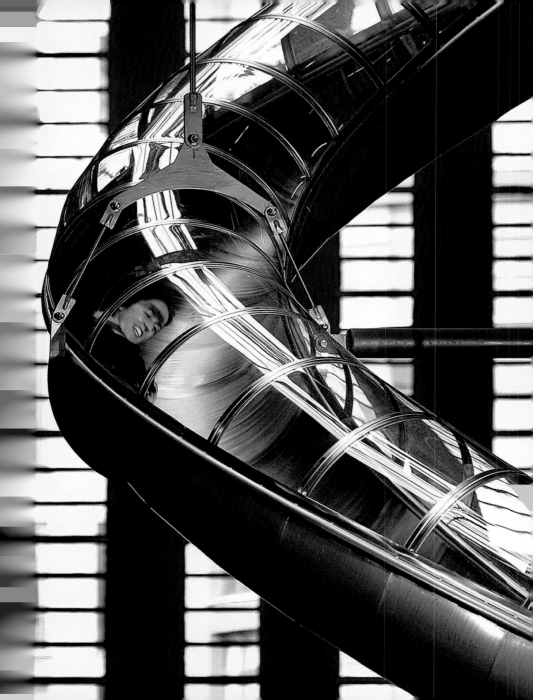

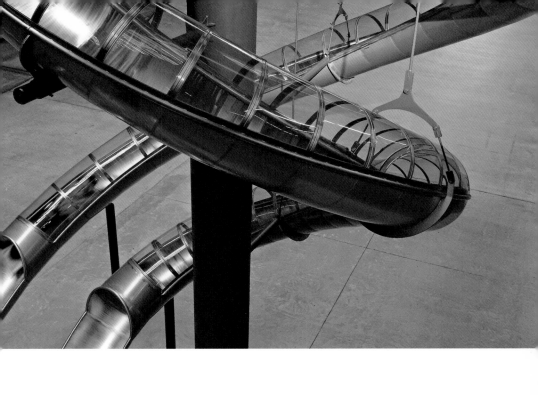

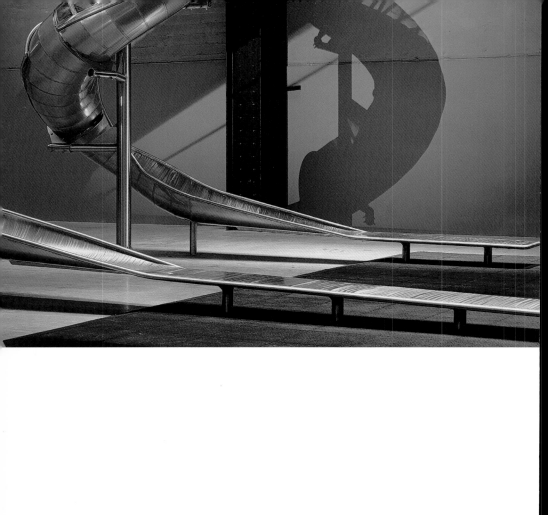

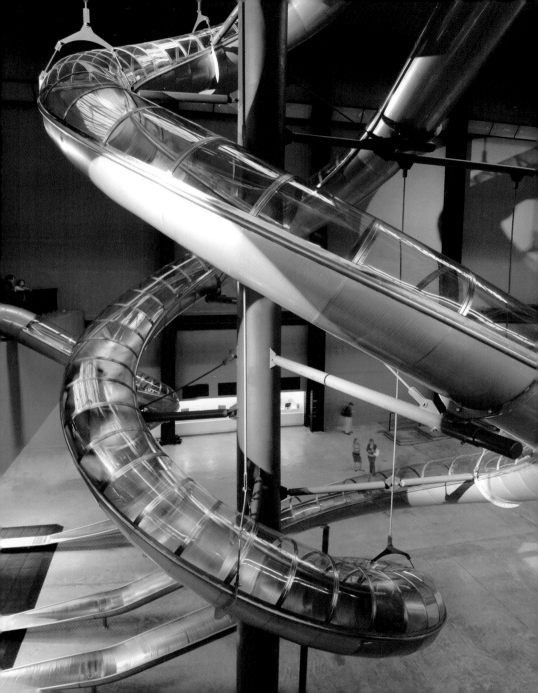

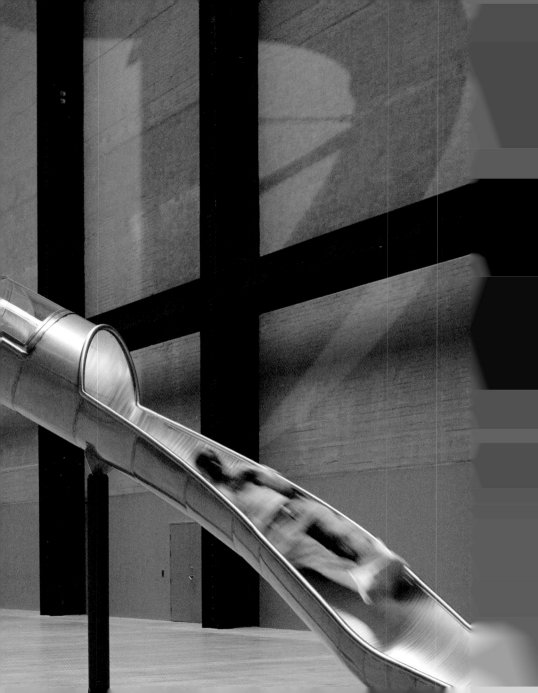

Elevations
Bibliography
Credits

Test Site Elevations

Below: View from east. Opposite: View from west. Josef Wiegand GmbH and Co. KG

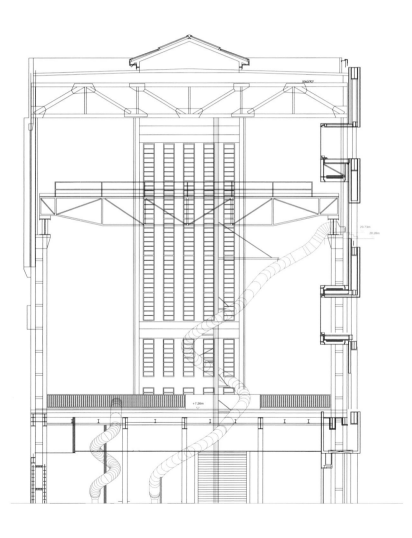

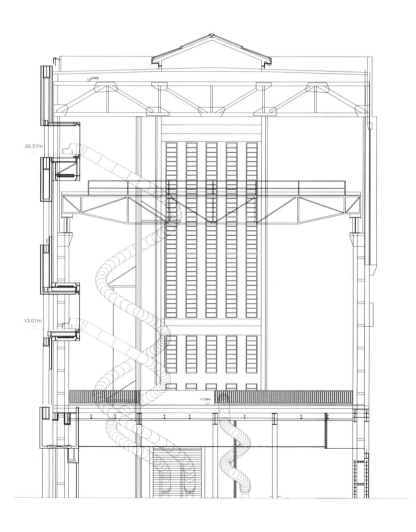

Jennifer Allen, 'Uncommon Senses,' Parkett 77, Oct. 2006, pp.39–51

Jessica Morgan, 'Would the Real Carsten Höller Please Stand Up?', Parkett 77, Oct. 2006, pp.28–38

Chantal Mouffe, 'Carsten Höller and the Baudouin Experiment', Parkett 77, Oct. 2006, pp.52–61

Jan Åman and Nathalie Ergino, One Day One Day / Une exposition à Marseille, Stockholm 2006

Dorothea von Hantelmann, 'Bruce Naumann und Carsten Höller' in Bruce Nauman: Mental Exercises, exh. cat., NRW-Forum Kultur und Wirtschaft, Düsseldorf 2006, pp.50–2

Germano Celant, 'Interview with Carsten Höller', in Carsten Höller: Registro, Fondazione Prada, Milan 2000, new ed. 2006

Anja Chávez, 'Carsten Höller: A Dialogue with Architecture' in Glenn Harper and Twylene Moyer (eds.), A Sculpture Reader: Contemporary Sculpture since 1980, Washington 2006, pp202–9

Chantal Pontbriand, 'Carsten Höller, Vertige: Le Kairos à l'oeuvre', Parachute, March 2006, pp.40–61

Adrian Searle, 'Fairground Distraction', Guardian, 6 September 2005, pp.11–12

Jennifer Allen, Carsten Höller: Logic, exh. cat., Gagosian Gallery, London 2005

Stéphanie Moisdon, 'Interview', Frog, no.1, Spring/Summer 2005, pp.30–8

Jennifer Allen, Sharing Space Dividing Time: Matias Feldbakken, Miriam Bäckström & Carsten Höller, exh. cat., Nordic Pavilion, 51st International Art Exhibition, Venice Biennale 2005, pp.14–19

Jennifer Allen, 'Carsten Höller: Musée d'Art Contemporain Marseille', Artforum International, vol.43, Nov. 2004, pp.43, 218–19

Alex Farquharson, 'Before and after Science', Frieze, no.85, Sept. 2004, pp.60–1, 91–5

Stéphanie Moisdon, 'La Beauté du doute', Beaux Arts, no.244, Sept. 2004, pp.60–5

Elizabeth Lebovici, 'Réflexion parallèles', Libération, 20 Aug. 2004, p.27

Ronald Jones, 'Miriam Bäckström and Carsten Höller', Frieze, no.80, Jan.–Feb. 2004, p.107

Jessica Morgan, Common Wealth, exh. cat., Tate Modern, London 2003

Carsten Höller, 'Doubt' (conference interview), in Hans Ulrich Obrist and Miyake Akiko (eds.), Bridge the Gap?, Kitakyushu 2002, pp.475–93

Jens Hoffmann, 'Carsten Höller: We Must Doubt!', Nu: The Nordic Art Review, no.4, Jan.–Feb. 2002, pp.130–7

Daniel Birnbaum, 'Mice and Man', Artforum, Feb. 2001, pp.114–19

Nicolas Bourriaud, 'Qu'est-ce que l'art (aujourd'hui)?', Beaux Arts, special issue, 2002, pp.156–8

Frank Frangenberg, 'Carsten Höller', Kunstforum, no.155, June–July 2001, pp.335–6

Jens Hoffmann, 'Carsten Höller: The Synchro System and you(s)', Flash Art, vol.34, no.218, May–June 2001, pp.130–3

Francesco Poli, 'Carsten Höller', tema celeste, no.83, 2001, p.104

Eric Troncy, 'Docteur Höller et Mr Hyde', Numéro, Dec. 2000–Jan. 2001, pp.199–203

Daniel Birnbaum, Production: A Discussion between Daniel Birnbaum and Carsten Höller, Kiasma, A Museum of Contemporary Art Publication, Helsinki 2000

Ulf Erdmann Ziegler, 'Speed of Life: Carsten Höller's Installation "New World Race"', Art in America, July 1999, pp.82–5

Daniel Birnbaum, 'A Thousand Words: Carsten Höller', Artforum International, March 1999, pp.102–3

Carsten Höller, Carsten Höller's Spiele Buch, ed. Hans Ulrich Obrist, Cologne 1998

Rosemarie Trockel and Carsten Höller, A House for Pigs and People / Ein Haus für Schweine und Menschen, Cologne 1997

Yvonne Volkart, 'Carsten Höller', Flash Art, vol.28, no.180, p.92

Michelle Nicol, 'Carsten Höller: Getting Real', Parkett 43, 1995, pp.8–17

Carsten Höller, 'Für die Liebe', Der Standard, June 1995, pp.6–7

Credits

Illustrations of works by
Carsten Höller

Fig.1
Light Wall 2000/2002, installation
in exhibition One Day One Day,
Färgfabriken, Stockholm 2003

Fig.2
Mirror Carousel 2005, installation
in exhibition Carsten Höller: Logic,
Gagosian Gallery, London

Fig.3
Video still from Jenny 1992

Fig.4
Valerio I 1998, installation at the Erste
Berlin Biennale, Kunst-Werke, Berlin
1998

pp.24–5
Valerio II 1998, installation at the Erste
Berlin Biennale, Kunst-Werke, Berlin
1998 (still on view); Female Valerio 1999,
installation in exhibition Children of
Berlin, P.S.1 Contemporary Art Center,
New York 1999; Slide No.5 1999–2000,
permanent installation at Prada Offices,
Milan; two views of Slide No.6 2003,
installation in exhibition Half Fiction,
ICA, Boston 2003

Fig.5
Valerio II 1998, installation at the Erste
Berlin Biennale, Kunst-Werke, Berlin
1998 (still on view)

Fig.6
Valerio III 2000, installation in
exhibition Slides, Kiasma, Museum of
Contemporary Art, Helsinki, 2000

Fig.7
Glück 1996, installation at Kölnischer
Kunstverein, Cologne 1996

Fig.8
Pages from Carsten Höller's Spiele Buch,
published by Oktagon Verlag, Cologne
1998

pp.30–1
Slide House Project (Independent
Monument Accra No.1/1) 1999

Slide House Project (Skyscraper Abidjan
No.1/2) 1999

Skyscraper Slide Connections 1998

Slide House Project (Marcel's Favourite
House Accra No.1/1) 1999

Slide House Project (National Theatre
Accra No.1/1) 1999

Slide House Project (Space House Accra
No.1/1) 1999

Fig.9
Flying Machine 1996, installation
view in exhibition A Kind of Magic,
Kunstmuseum Luzern, Lucerne 2005

Fig.10
Upside-Down Mushroom Room 2000,
installation in exhibition Ecstasy: In and
About Altered States, MOCA,
Los Angeles 2006

p.36
Round Slide House (1:100 Model) 2000,
installation view in exhibition Slides,
Kiasma, Museum of Contemporary Art,
Helsinki 2000; Maison Ronquières 2000,
installation view in exhibition Carsten
Höller: Synchro System, Fondazione
Prada, Milan; Atomium Slide House
2003

All works reproduced courtesy:
Air de Paris, Paris
Casey Kaplan, New York
Esther Schipper, Berlin
Fondazione Prada Collection, Milan
Fonds National d'Art Contemporain,
Paris
Gagosian, London, New York
Galerie Micheline Szwajcer, Antwerp
Galleria Massimo de Carlo, Milan
Shugoarts, Tokyo
Private collection, New York
Private collection, Paris

Photo credits

Test Site Installation:
Attilio Maranzano; Getty Images;
Tate Photography: Sam Drake; Andrew
Dunkley; Marcus Leith; Oliver Leith

Other works by Carsten Höller:
Christian Bauer; Duggal Labs; Stefan
Frank Jensen; Attilio Maranzano; Bill
Orcutt; Adam Reich; Barney Schaub;
Petri Virtanen; Suara Welitoff; Jens Ziehe

Other illustrations:
© The Bridgeman Art Library (fig.11)
Courtesy of the Museum of the City of
New York (fig.13)
Courtesy of Smith Memorial Playground
and Playhouse, Philadelphia (fig.16)
© John Drysdale (fig.17)
Courtesy of The Isamu Noguchi
Foundation Inc. Photo Credit: © 1994
William Taylor (fig.18)
© Mike Horton (fig.19)
Courtesy of Art and Architecture
Archive © Tim Benton (fig.22)

Copyright credits

sten
er

22-May-07 /techette 8-97 (14.95) 10/6 45